LIVING PAINT

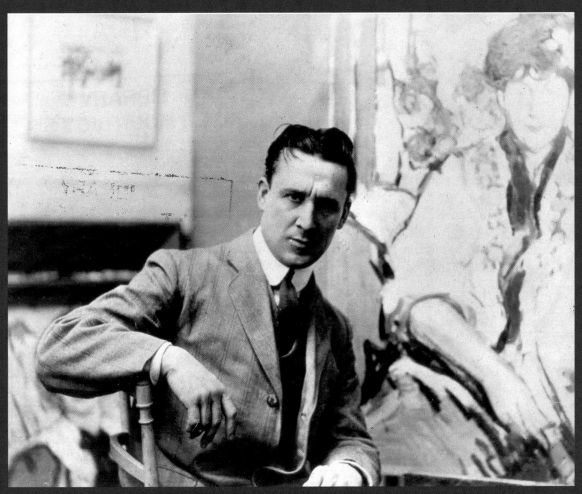

J.D. Fergusson, Paris
studio, 1910

*The Glasgow School . . . had the Scots' characteristic of
independence, and vigour, colour and particularly quality of
paint, which means paint that is living and not merely any coat
of paint placed between containing lines like a map.*
 John Duncan Fergusson, Modern Scottish Painting, *1943*

LIVING PAINT
J.D. FERGUSSON 1874–1961

KIRSTEN SIMISTER

MAINSTREAM
PUBLISHING

EDINBURGH AND LONDON

First published in Great Britain in 2001 by
MAINSTREAM PUBLISHING COMPANY (EDINBURGH) LTD
7 Albany Street
Edinburgh EH1 3UG

ISBN 1 84018 374 8 (hardback)
ISBN 1 84018 398 5 (paperback)

A catalogue record for this book is available from the British Library

Designed by Janene Reid
Typeset in Gill Sans and Adobe Garamond
Printed and bound in Great Britain by The Bath Press Ltd

CONTENTS

FOREWORD

As Chairman of the J.D. Fergusson Art Foundation, I am delighted to support the publication of the first fully illustrated catalogue of the Fergusson Gallery collection. To the few of us remaining who were lucky enough to have known the artist personally, it is a particularly gratifying occasion.

Over the past decade, we have witnessed the gradual realisation of several of Fergusson's most dearly held dreams. These have resulted, in no small part, from the integrity and boldness of his far-sighted, personal vision. On his death in 1961, Fergusson left the largest and single most important collection of his works to his lifelong companion, Margaret Morris. Numbering several thousand items, this included oil paintings, water-colours, drawings, sketchbooks and sculpture, and represented all aspects and phases of his experimental and varied output. In 1963 Morris estab-lished the J.D. Fergusson Art Foundation to enable the artworks to be administered on her behalf.

The process entered a new phase when the foundation gifted its substan-tial holdings, plus associated archive, to Perth and Kinross District Council in 1991. Since the Fergusson Gallery's opening in March of the following year, it has staked its place firmly on the nation's cultural map. Its growing popularity has brought his remarkable artistic talents to an ever-widening and apprecia-tive audience. In securing this permanent home we successfully fulfilled our primary objective.

In 1995 things were taken one step further with the creation of the J.D. Fergusson Arts Awards Trust. In keeping with Fergusson's wishes expressed in his will, the trust exists to provide financial assistance and encouragement to deserving Scottish artists who have not been recognised or become part of the 'establishment'.

The Foundation's ongoing support of the work of the Fergusson Gallery in the form of the sponsorship of this illustrated book recognises its vital

contribution towards realising the potential of J.D. Fergusson's rich artistic legacy.

We would like to acknowledge the valuable work of Kirsten Simister, who has had charge of the Fergusson collection since 1991 to the entire satisfaction of the J.D. Fergusson Art Foundation. She has made full use of the material and the information and has undertaken all the work in preparation of *Living Paint*. After living with the collection for almost a decade she is uniquely qualified to be the author.

Louise Annand MBE
Chairman, J.D. Fergusson Art Foundation
2000

ACKNOWLEDGEMENTS

The realisation of this book has been made possible by the efforts of many people over a number of years. Above all, I am particularly grateful to Sheila McGregor, who in the course of her research has consistently drawn my attention to significant new information. She has also generously provided me with access to the text of her forthcoming monograph on the artist, which has closely informed the following essay. Her detailed and thorough study sheds light on many important aspects of Fergusson's career, including the complex area of his early works. I am also indebted to Roger Billcliffe for kindly agreeing to undertake the introduction and to Robin Rodger, Principal Officer Fine and Applied Art, for providing the history of the Fergusson Gallery.

With respect to both J.D. Fergusson and Margaret Morris, I have been fortunate to meet many who knew them personally and have given freely of their time and energy to share their memories. Most notably, I wish to acknowledge the valuable contribution of Louise Annand and Robin Anderson, both of the J.D. Fergusson Art Foundation, and Jim Hastie of the Margaret Morris Movement. This trio have patiently endured my queries over the years, providing a wealth of information, especially relating to the artistic activities of both Fergusson and Morris in Glasgow during the 1940s and '50s. Through them, I have been introduced to others whose accounts have further enriched my appreciation and understanding of the lives and work of Fergusson and Morris. Amongst them are: Dympna Avella, Margaret Finlay Fergusson, George Girvan, Bet Low, Kim Redpath, Bill Rennie, Anne Robertson, Carlo Rossi, William Senior, Anne Cornock-Taylor, Olive Thomson, Janet Wilkie, Robert Blair Wilkie, the late Martha Arnott, Dr Kenneth Ireland, Thomas Halliday, William McLellan, Professor Robert Silver and family members of the late Marie de Banzie, Margaret Oliver Brown, Morris McChlery, Nathaniel Smith, and William Vannet.

I would also like to thank the staff of the following institutions for their courteous help in providing photographic transparencies: the City Art Centre (Edinburgh), the McManus Galleries (Dundee), the Hunterian Art Gallery (University of Glasgow), Glasgow School of Art, the National Galleries of Scotland and the University of Stirling.

My special thanks go to the numerous colleagues who have been closely involved with the production of the catalogue: from Paul Adair, for calmly and efficiently undertaking all the photography, to Robin Rodger and Annette Carruthers, for their encouragement, invaluable advice and proofing of the draft stages of the text, and finally, to the staff at the Fergusson Gallery, for their unflagging levels of technical, administrative and moral support over the past months.

On behalf of Perth and Kinross Council, I would like to acknowledge the crucial role played by the J.D. Fergusson Art Foundation, which continues to support the development of the Fergusson Gallery in numerous ways, not least by generously funding the production of this publication.

Kirsten Simister
Fine and Applied Art Officer
The Fergusson Gallery
2000

INTRODUCTION

Many aspects of Fergusson's social background, personality and professional career set him apart from his associates. Despite his undoubted individuality, Fergusson also shared qualities with each of the Colourists. Like Hunter he was self-taught, or the product of repeated short-term enrolments at painting academies in France and Scotland. Peploe and Cadell both had more conventional training, and Cadell was a family friend of that great master of colour among the Glasgow Boys, Arthur Melville. Like Hunter, Fergusson had few well-placed social contacts who would assist his career, unlike Peploe and Cadell who came from solid middle-class backgrounds in Edinburgh. As young contemporaries in Edinburgh who were to make regular painting trips together around Scotland or to France, Peploe and Fergusson shared the discovery of Manet and French painting of the mid-nineteenth century. Together they developed a new vocabulary, influenced no doubt by that of the Glasgow Boys, idols for each of these young artists. But their tastes gradually began to diverge as Fergusson was drawn to Whistler and Peploe to a more historical tradition of still life painting, in which he made a considerable reputation in Scotland prior to 1910.

Had Fergusson had such a close relationship with Hunter, rather than Peploe, then the careers of all three artists might have taken a different direction. Hunter was a volatile but intuitive painter, unafraid to experiment but whose work is ultimately variable in quality. He would have learned much from Fergusson – a disciplined approach to working, the importance of reflection and drawing – and he would also have given Fergusson a sounding board for the many theories that raced through his mind and which occasionally failed to find resolution on the canvas. Cadell could have brought to Fergusson a lightness of touch, sometimes sorely needed, while himself learning that artists also have a responsibility to themselves and their art and not just the fashionable demands of the society which buys their pictures.

And without Fergusson's encouragement to join him in Paris, would Peploe have developed into the consummate painter of still life that he became in the 1920s?

In many ways the 1920s is the decade of the most assured work by the other Colourists, when Peploe produced his great series of still lifes, Cadell the magisterial interiors of Ainslie Place such as *The Orange Blind*, and Hunter blossomed into a painter of consequence and talent after his visits to the south of France. Fergusson, however, had produced his masterpieces in Paris before 1914 when he was so in tune with the vitality of the city and its avant-garde artists. They are works on a different plane where, in paintings such as *Rhythm* and *At My Studio Window*, he showed his assimilation of the advances made by the masters of French painting, an awareness and achievement unequalled by any of his Scottish contemporaries. And, of course, his very longevity, dying more than twenty years after the longest-lived of the other three artists, made Fergusson such an influential figure among the younger generations who joined him and his companion Meg in their New Art Club in Glasgow. Their adulation and exuberance undoubtedly helped keep Fergusson young and kept his achievement alive in the decades after 1945 when the paintings of the Colourists began to fall out of fashion with young painters passing through the Scottish art schools.

The Colourists gave Scottish painting much of its direction in the first half of the twentieth century. They cemented the relationship with France which the Glasgow Boys had established and turned the heads of the Scots firmly towards France, until the work of American artists so deservedly drew the attentions of a younger generation in the 1970s. Fergusson, in both his artistic and his intellectual grasp of these vital developments, made sure that Scotland did not return to the artistic backwaters where it had languished fifty years earlier. Scottish art and artists owe much to him and this volume will surely and deservedly place his lasting achievement on record.

Roger Billcliffe

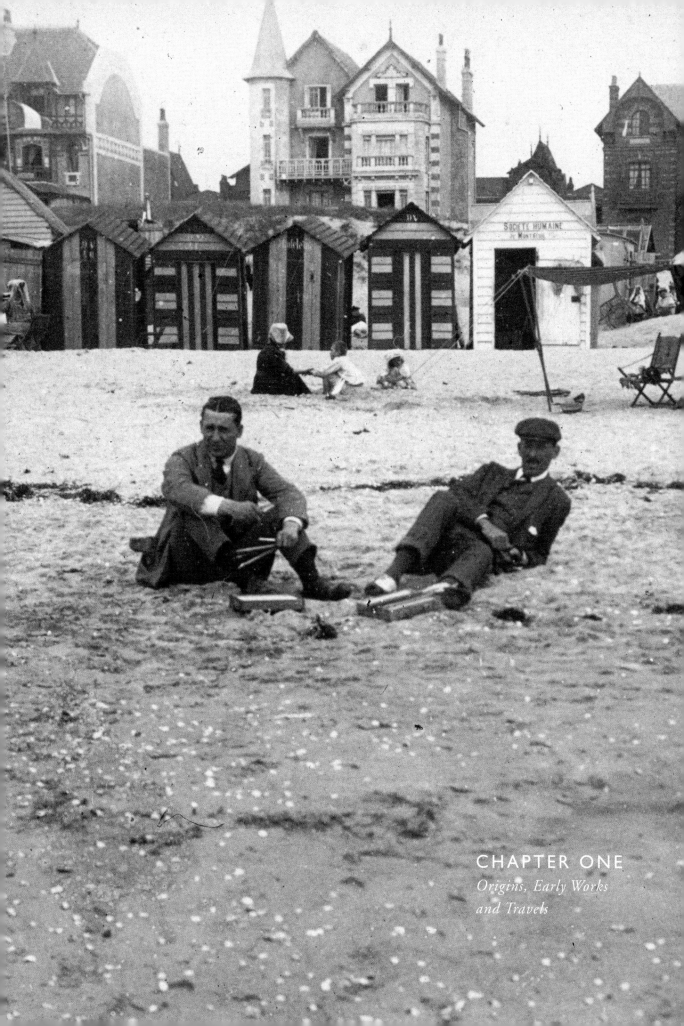

CHAPTER ONE
*Origins, Early Works
and Travels*

John Duncan Fergusson was born at 7 Crown Street in Leith, Edinburgh, on 9 March 1874. He was the eldest of four children, with two sisters, Elizabeth and Christina, and a younger brother, Robert. His parents, John and Christina Ferguson, had moved from Pitnacree near Pitlochry shortly before his birth, and in later life Fergusson was to place great emphasis on his Highland ancestry. It was Perthshire which he later claimed as his spiritual home and his happy memories of childhood holidays visiting relations in the area acquired an almost mystical tone.[1]

His father was Ferguson, spelt with one 's' and this is the version inscribed on his son's birth certificate. His mother, however, had the same maiden name but spelt with a double 's' and this was the spelling that the artist himself adopted around 1900, probably because he felt it to be the more Celtic. Although Fergusson referred to his father as a Perthshire farmer, which was indeed true prior to the move to Edinburgh, he never mentioned his subsequent career. In fact, he had owned a spirit merchant's shop in Cockburn Street. Three changes of family address during the 1880s and '90s indicate gradually improving prospects and suggest a relative degree of prosperity by the time his father died in 1906.

Fergusson told how his love of art as a boy was encouraged by his mother, who took him on visits to the Royal Scottish Museum in Chambers Street and the National Gallery on the Mound. In 1886 he enrolled at the Royal High School in Edinburgh and three years later moved to Blair Lodge, a boarding school near Linlithgow. It is here that his interests in Art and French were encouraged.

Fergusson maintained that on leaving school he had studied medicine in Edinburgh, with the intention of becoming a naval surgeon. The story went that he failed his second-year exams because he spent too much time drawing caricatures of his professors. Such a career path would no doubt have been encouraged by his parents, in preference to the precarious alternative of art, but there are no records of his matriculation at the University. It may be that he embellished this aspect of his past. His links with Edinburgh University

PREVIOUS PAGE

Peploe and Fergusson, north-west France, c.1905

may have existed but to no greater extent than perhaps attending occasional anatomy classes to draw. The source of this contact may have been one of his close friends, John MacMillan Marshall, who was a medical student at the university and the sitter for an early oil painting.

Whatever the actual facts, Fergusson took up his passion for art around the mid-1890s. Although accepted by the Trustees' Academy, the forerunner to Edinburgh College of Art, he gave up his formal training after only a few weeks. The classes involved two years of study from plaster casts, a strict discipline against which he rebelled. By contrast, he was keen to work directly from life and showing characteristic independence of mind, he thereafter taught himself.

Until his late twenties, Fergusson lived at home at 16 East Claremont Street, on the fringes of Edinburgh's New Town. Rooms at the top of the house were converted into a studio for him and it was not until 1902 that he moved to his first studio in Picardy Place at the top of Leith Walk. The attic rooms looked out over the Firth of Forth and Fergusson painted the walls a pale shade of grey. According to his autobiographical notes his first works were watercolours. The modest study *Our House* (PL 1 CAT 167) is from this earliest phase of his artistic development.

From a very early stage in his career travel was to provide a crucial spur to his artistic development. His work began to be informed through his direct experiences of contemporary French art. Exactly when he made his first trip to Paris has long been debated. It was most likely 1897. The likelihood of a recent visit is backed up by the fact that he exhibited French subjects for the first time the following year at the annual exhibitions of both the Royal Scottish Academy and the Society of Scottish Artists.

A slightly later watercolour study, *The Trocadéro, Paris* (PL 97 CAT 168) demonstrates a marked development in terms of Fergusson's technical assurance and the sophistication of the resulting image. It depicts the Palais du Trocadéro, built to celebrate the Paris Exhibition of 1878 and was a well-known landmark of the day. Viewed in subdued light, the atmosphere and

mood of the scene are emphasised using broad washes of blue with touches of green.

In keeping with other early works, both the simplified treatment and the subject matter reveal the influence of the American artist, James Abbott McNeill Whistler. This particular example evokes his famous series of *Nocturnes*, based on the river Thames. Fergusson's writings reveal his enormous admiration for him, not only artistically but also as something of a role model. Whistler was a rebel figure who stood apart from the art establishment, challenging traditional methods and received ideas. In his book *Modern Scottish Painting*, Fergusson comments:

> *Here was a man, a fighter, a man of feeling, of sensibility, not muddleheaded enough to be impressed by the academic imbecilities. A man with a real sense of design, a real sense of colour and quality of paint* [see The Little White Girl].
> *It was easy for the Glasgow men to accept his beautiful greys, and saw that his*

1 *Our House*, c.1897
CAT 167

sense of design was something that was a great help to them. His art was obviously not very full blooded, but it had spirit, and wit, if not humour . . . His art was the twilight, the Celtic twilight, brought to Chelsea . . . It was the white mist and compared to the art of the time in Britain, amazing and charming.[2]

Nocturne: Blue and Gold – Old Battersea Bridge, 1872–1877, James Abbott McNeill Whistler
oil on canvas
683 mm x 512 mm
TATE BRITAIN, LONDON

As he acknowledges, he was not the first to admire Whistler, whose example had already made an impact on a previous generation of Scottish painters, the Glasgow Boys. In fact, there is much to link Fergusson's early work and practices with the innovative precedents that they had established. In particular, he wanted to ally his painting methods with the broad, simplified handling characteristic of their work. Their methods deliberately challenged the degree of finish demanded by the art academies and official institutions of the day. The sheer bravura of paint displayed in works such as *Packet of Matches and Match Box* (PL 117 CAT 2) demonstrates the impact of their influence. In addition, the sombre colour and stress on tonal values shows the influence of seventeenth-century Dutch painting, as well as the work of the French Impressionist, Édouard Manet. Fergusson's notes consistently mention how he was inspired by viewing Manet's work in the Salle Caillebotte and Durand Ruel's Gallery. Even in this study of the most humble and everyday subjects, the sensuality of Fergusson's underlying approach is apparent. The thick, creamy texture of paint, which he preferred, is very much in evidence. As he put it, 'This substance is reality, it is the fullness and richness of things made apparent to the painter by light and creates a feeling of the fullness of things, like rich earth, foliage, clouds etc.'[3]

This enjoyment of the very substance of the medium best explains Fergusson's almost exclusive focus on oil paint from the early 1900s onwards. According to his notes, the initial transition was also influenced by a chance meeting with Alexander Roche, who invited him to visit his studio and lent him an oil sketch of Velazquez's *Las Meninas*.

The most significant link between the Glasgow Boys and Fergusson's early artistic development was provided by Arthur Melville, one of the most

brilliant British watercolourists of his generation. Of more importance than his style was a shared spirit of invention and exploration. Fergusson referred to Melville as his first influence, explaining, 'Although I never met him or saw him, his painting gave me my first start; his work opened up to me the road to freedom not merely in the use of paint, but freedom of outlook.'[4]

It was Melville's travels to Spain and Morocco that inspired Fergusson to undertake the same journey. It is thought that he made two separate trips, first to Morocco in 1899 and second to Spain in 1901. The general focus of works such as *Arab Fishermen and Boats* (PL 106 CAT 3) remains on the careful orchestration of tonal values within a limited colour range. However, the introduction of notes of bright red and green shows an awareness of the power of pure colour, revealing further links with the Glasgow Boys, and pointing the way to Fergusson's future artistic direction.

There are only a handful of surviving paintings relating to the Spanish trip, two of which are *Spaniard* (PL 2 CAT 24) and *Spanish Senorita in Mantilla* (PL 3 CAT 25). Both are modestly scaled oils on board, the latter distinct in technique having been painted using square-ended brushes, which seems to have been a one-off experiment at the time.

Outwith his travels, Fergusson continued to draw artistic inspiration from his base in Scotland. This tended to focus on family and friends and the local surroundings. All were subjects that he tackled while familiarising himself with oil paint. He was particularly attracted to the lively atmosphere of Princes Street Gardens, which provided the setting for numerous early works.

Showing characteristic pragmatism, he converted a cigar box to hold one or two 5" x 4" panels, alongside paints and cut-down brushes, with the lid of the box doubling as his palette. With this portable paint-box he was free to record scenes spontaneously as and when he chose, often working outdoors as he preferred to do at this stage. The collection in Perth contains over twenty examples of these small but boldly painted panels which include: *Red Braces: Self Portrait* (PL 60 CAT 15), *Lamplight* (PL 61 CAT 11), *Girl in Field* (PL 88

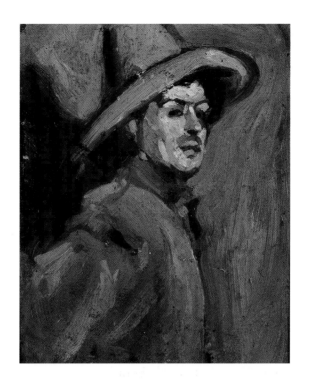

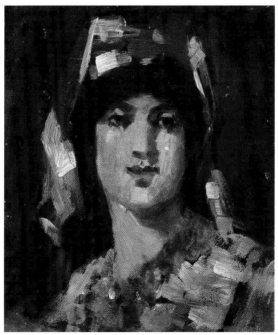

2 *Spaniard*, c.1901
CAT 24

3 *Spanish Senorita in
Mantilla*, c.1901
CAT 25

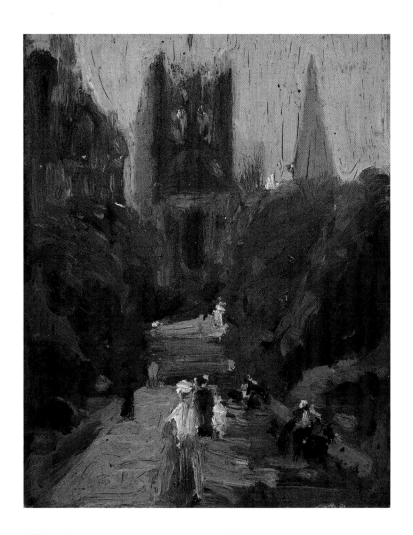

4 *Princes Street Gardens,*
 Edinburgh, c.1900
 CAT 14

West End of Princes
Street, Edinburgh, 1897

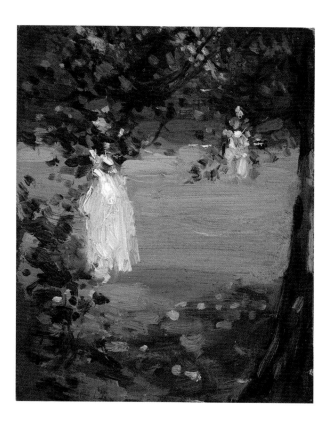

5 *White Dress in the Garden*, c.1900 CAT 22

CAT 10), *White Dress in the Garden* (PL 5 CAT 22), and *Satyr* (PL 89 CAT 17). Many are undated and vaguely titled and could have been inspired by either Scottish or French subjects. Some, such as *Girl in Field*, reveal an increasing desire for vibrant colour. In the case of *White Dress in the Garden*, the treatment is surprisingly abstract, exploring the relationship between colours and brushstrokes with only minimal reference to subject matter. Such works demonstrate his interest in the expressive potential of colour, line and shape for their own sake. This focus on the formal values of painting became a consistent feature of his work and grew more dominant as time went by.

According to Fergusson, his contact with Paris was established by visits made there each May, using money that his father gave to him. This was not unusual or radical for British artists of the late nineteenth century. During the

1880s Paris was already the undisputed world capital of art and attracted many British artists to study in its famous *atelier* system. Fergusson's early trips can, in part, be viewed in this context. Unlike his predecessors, however, he had very little contact with the art schools, as he found the teaching too academic. Of far greater importance was the atmosphere and lifestyle that Paris offered and which contrasted so markedly to that which existed in both Edinburgh and London.

Fergusson was a prolific recorder, not only visually but verbally as well. His notes convey the sense of excitement and discovery, which marked his visits:

> *I immediately found there, what the French call an 'ambience' – an atmosphere which was not only agreeable and suitable to work in, but in which it was impossible not to work! I saw the Impressionists in the Salle Caillebotte, Manet, Renoir, Monet and the rest. In the Caillebotte Gallery [really a shed] there were large open ventilators under the picture line, showing the light on the leaves in the garden and letting in the sunshine and air harmonising very well with the pictures . . . I painted in the Luxembourg Gardens, on the quais, and barges. I knew boats, I liked the open air and the idea of being in an art school didn't suit me at all. I was attuned to the movement of water and light on water . . . The creamery where I ate had good pictures on the wall. Then there was the Indépendents . . . There I saw new points of view in painting – for example an Odilon Redon with animals in the sky . . .*
>
> *I met an Englishman who took me to the creamery we called 'The hole in the wall' [this] changed Paris for me – from being entirely alone to being with a wonderful group of artists, mostly with bursaries from different countries . . . We had early lunch and late dinner and between meals painted or went around the galleries.*[5]

The most direct artistic influence on Fergusson during his early years undoubtedly came from his close friendship with the painter, Samuel John

Peploe (1871–1935). It is likely that they met around 1900, possibly at the studio club run by the caricaturist Joseph Simpson in Edinburgh. Fergusson described their relationship as, '…wonderful and interesting all the time. Nothing about it was spectacular. It was merely a happy unbroken friendship between two painters who both believed that painting was not just a craft or profession, but a sustained attempt at finding a means of expressing reactions to life in the form demanded by each new experience.'[6]

Initially, Fergusson took his lead from Peploe, who was three years older and the more widely read and travelled. Fergusson's notes record:

> *Before we met, Peploe and I had both been to Paris – he with Robert Brough and I alone. We were both very much impressed by the work of the French Impressionists, whose work we saw in the Salle Caillebotte in the Luxembourg and in Durand Ruel's Gallery. Manet and Monet were the painters who fixed our direction – in Peploe's case Manet especially. He had read George Moore's* Modern Painting *and Zola's* l'Oeuvre*, I had read nothing about painting.*[7]

During the early 1900s Peploe and Fergusson began to make regular summer trips to Paris and the fashionable coastal resorts of Normandy and Brittany in the north west of France. They would often set up easels side by side, producing finished works of the same view which are difficult to tell apart. Their travels took them to Paris Plage, Dieppe and Étaples, amongst other places. Working *en plein air* in the manner of the French Impressionists, their palettes became paler and fresher and their brushwork more fluent in handling. They developed the facility to convey the essence of their subject matter with breathtaking simplicity using thick, creamy paint, applied with seemingly effortless skill [See *Paris Plage* (PL 9 CAT 40)].

Portraiture was another significant interest for Fergusson during the early 1900s and again there are strong parallels with Peploe's work. He embarked on a series of impressive, full-length portraits around 1904 including the imposing, *The White Dress: Portrait of Jean* (PL 63 CAT 37). Fashionable and

Peploe and Fergusson, c.1905

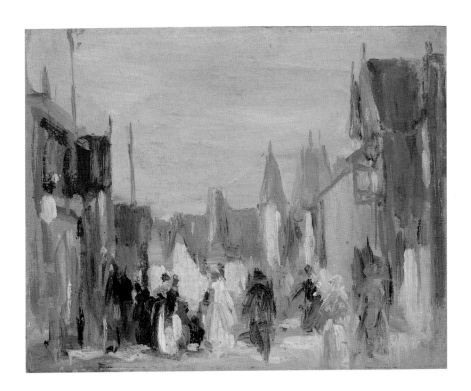

6 *French Village with Figures*, c.1903 CAT 28

elegant, this and similar portraits evoke comparison with works by Whistler, John Singer Sargent and Manet. Fergusson's models were drawn almost exclusively from his family and friends and the sitter for this work was Jean Maconochie, whom Fergusson painted on several occasions at this time. A second oil painting, *Jean: The Cock Feather* (PL 62 CAT 30) depicts her in a large, stylish hat, adorned with glossy plumage that prefigures his many flamboyant hat portraits of the Paris years. A series of studio-shot portraits from the archive shows her dressed in a variety of different outfits, whilst one with a personal message on the back and another of her nude, suggests a more intimate involvement.[8] This is confirmed by a letter of 1959, in which Fergusson reminisces affectionately about his youth. In it, he refers to Jean as one of his very best memories adding, 'which I'd like to elaborate but won't!'.[9]

The influential critic of *The Sunday Times* and *Art News*, Frank Rutter, was one of Fergusson's most important early supporters. He noted that

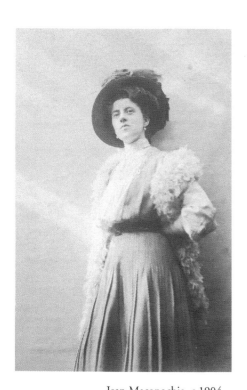

Jean Maconochie, c.1904

7 *The Feather Boa*, 1904
oil on canvas
2020 x 998 mm
UNIVERSITY OF STIRLING

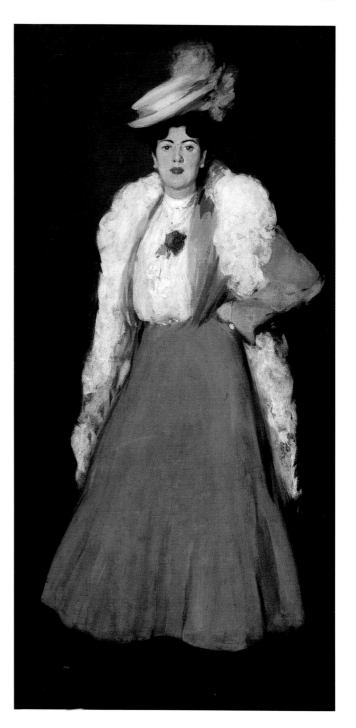

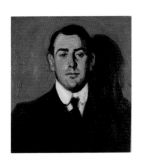

8 *John Baillie*, 1904
CAT 34

Fergusson could have made a successful career move to London had he wished to pursue this direction but, again like Peploe, he chose not to exploit the financial rewards to be gained from commissioned work.

In 1905, Fergusson's artistic confidence was boosted by his first solo exhibition, which was held at the Baillie Galleries in London. Amongst his 56 exhibits were 16 paintings of Paris Plage, a location that remained a favourite with him over the years to come. The importance of light, central to the work of the Impressionists, was echoed in his introductory statement to the catalogue. This is probably the closest he came to setting down the fundamental artistic principles guiding his work. It begins, 'He (the artist) is trying for truth, for reality, through light. That to the realist in painting, light is the mystery; for form and colour which are the painter's only means of representing life, exist only on account of light.'[10]

Following the success of his exhibition Fergusson began to spend longer in Paris but did not actually move there for another two years. On his own account, his desire to move to France permanently was prompted by a very favourable review of his work published in *The Studio* magazine. The writer of this piece was Haldane MacFall and his praise was indeed glowing, 'I know of no living painter with a more profound feeling for the music that is in colour. The joy in life, and the joy in stating it, are everywhere. It must be a rare delight to reach such power and achievement and still be young. Art such as this must live.'[11]

His father's death in 1906 may also have been significant due, partly, to provision left in his will towards his children's 'maintenance, education or advancement in life'. However, to finance his move Fergusson was still obliged to sell a gold watch given to him by his father, along with a complete set of Aubrey Beardsley's *Yellow Book* and his studio furniture. Fergusson was now poised, about to embark on the most fruitful phase of his career. Few British artists were to witness so directly the explosive creative energies of the art scene in pre-war Paris. Fergusson was ideally placed to take full advantage of the opportunity.

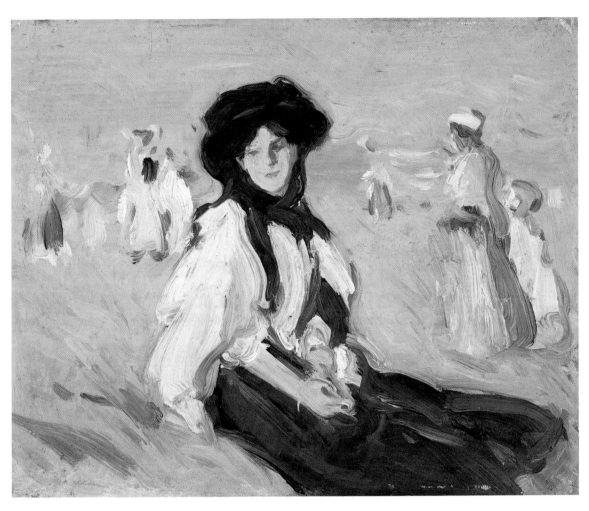

9 *Paris Plage*, 1907 CAT 40

The Studio magazine,
1907 FERGUSSON ARCHIVE

By choosing to teach himself, he had already demonstrated his ability for independent thinking and shown the first signs of a rebellious streak. His tendency to question authority remained strong throughout his life, whilst his hostility towards art academies and official art in general was also evolving. He was the kind of personality prepared to take risks and despite his skill as a portrait painter, he kept his priorities firmly focused on his own artistic agenda. His belief in the guiding principle of freedom, in art as in life, was to be absolutely fundamental.

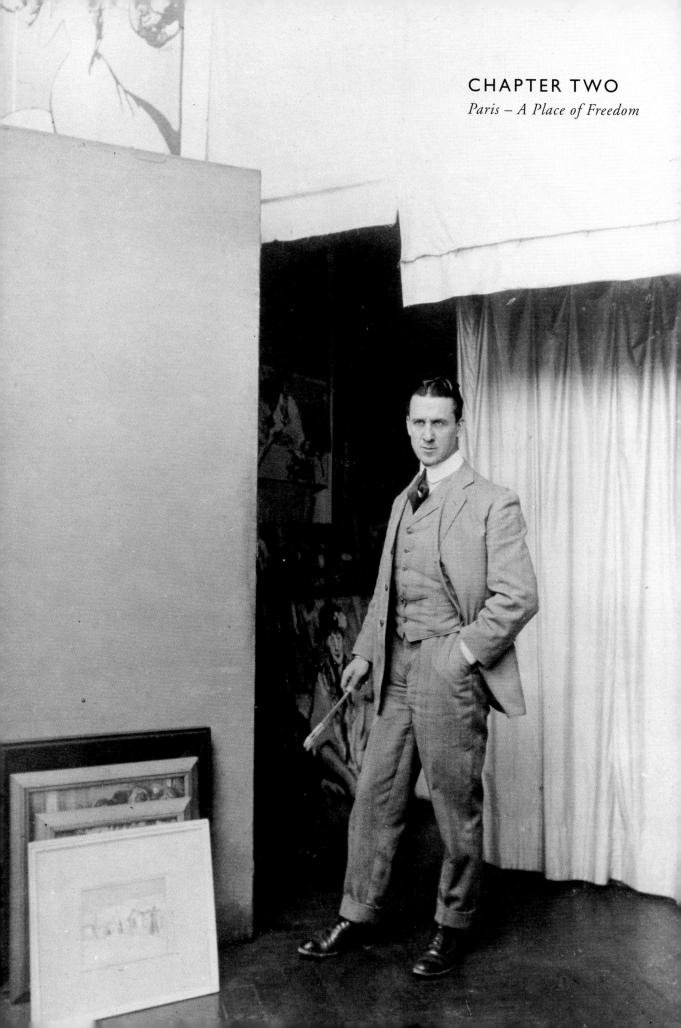

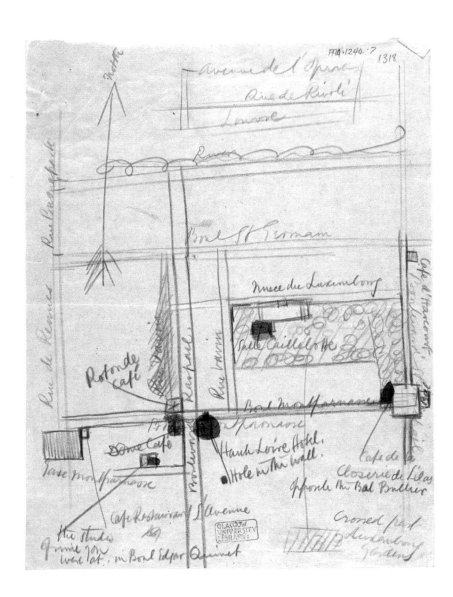

Fergusson's hand-drawn
map of Montparnasse

PREVIOUS PAGE

Fergusson in his Paris
studio, c.1910

Pre-war Paris had a special magnetism, drawing individuals from abroad from all cultural spheres and creating the opportunity for unparalleled levels of creativity, exchange and debate. It was an era marked by artistic ferment and change, when many long-held traditions and values were rethought and revolutionised. In short, this unique and dynamically charged atmosphere ushered in what is commonly referred to as Modernism. It was, above all, the sympathy of the French in terms of their acceptance and freedom of outlook to which Fergusson responded.

> *Paris is simply a place of freedom. Geographically central, it has always been a centre of light, learning and research. It will be very difficult for anyone to show that it is not still the home of freedom for ideas; a place where people like to hear ideas presented and discussed; where an artist of any sort is just a human being like a doctor or a plumber, and not a freak or madman.*[12]

His first base was on the Left Bank in the district of Montparnasse, which had begun to attract growing numbers of artists in preference to Montmartre, which had previously been the main artistic centre. His studio in boulevard Edgar Quinet overlooked the local cemetery and the view from his window is recorded in a painting of that year, *Boulevard Edgar Quinet, Paris* (PL 100 CAT 39) showing significant stylistic developments.

Artistically, the Fauves were to be the group of painters who made the greatest impact on him. Their work had caused a sensation when first exhibited at the Salon d'Automne in 1905. They shocked critics and public alike with their dazzling use of colour and deliberately unrefined painting techniques. The apparently violent and savage expression of their emotions on canvas led one critic to liken them to wild animals. His unintentional christening of 'les Fauves' proved to be lasting. Although not initially regarding themselves as a group, Henri Matisse, André Derain and Maurice de Vlaminck were the chief figures associated with the style's development between 1904 and 1908. By the time of Fergusson's arrival, they had estab-

10 *Café Interior*, c.1908
 CAT 218

lished themselves as the leaders of the Parisian avant garde. He would already have had the chance to become familiar with their work at the annual exhibitions of the Salon d'Automne and the Salon des Indépendants. The fact that Paris had this public platform to display potentially shocking images impressed him, provoking his response, 'The Indépendants is open and almost every conceivable kind of painting is represented . . . the point of the Indépendants is the extraordinary or the Extreme, what other exhibitions will not accept'.[13]

A naturally gregarious and extrovert personality, Fergusson spent much of his time in the cafés and bars near his studio. His openness and receptivity to new and diverse influences was to be crucial and he thrived on the opportunity to share and develop his ideas through discussion. He soon made contact with like-minded individuals, including some of the leading figures of the avant garde. Amongst his acquaintances were Pablo Picasso, Othon Friesz, André Derain and the sculptor, Antoine Bourdelle. Through teaching at the Académie de la Palette, he also met André Dunoyer de Segonzac, who was to become a close lifelong friend.

Throughout these years Fergusson sketched constantly in pocket-sized

notebooks. Conté was his preferred medium due to its versatility. A mixture of graphite and clay, the narrow sticks could be sharpened to a point and used to create a great variety of tones and effects, ranging from intense, dark lines through to subtly suggested shadows. Fresh and direct in treatment, his rapidly drawn portrait heads are incisively observed and superbly skilled in their economy of line. Many display a warm humour and wit, while others are caricatures, striking a satirical note not found elsewhere in his work. In treatment, they forge a close connection with the work of French contempo-

11 *Seated Woman*, c.1910
CAT 265

raries such as Henri de Toulouse-Lautrec. Aside from part-time teaching, Fergusson supplemented his modest income with the occasional sale of a painting or drawing to Paris dealers. The drawings were often enlarged versions of sketches, some with added washes of colour. He was also briefly involved with illustration work between 1908 and 1909, securing himself a regular salary by providing head and tailpiece decorations for an American trade magazine. Eventually the necessity to meet strict deadlines, coupled with his own determination to provide only his best work proved too demanding and he gave up the contract in order to devote more time to his painting. His sketches of Blériot's historic flight across the Channel on 25 July 1909 were among the last pieces of design work he undertook at this stage.

His close circle of friends were mainly British and American and despite the financial hardships, the impression Fergusson gives of his Paris years is charmed and magical:

> *This was the life I had always wanted and often talked about. We were a very*
> *happy group: Anne Rice, Jo Davidson, Harry and Bill McColl, Yvonne and*

12 *Caricature of S.J. Peploe*, c.1910 CAT 349

13 *Woman in Hat*, c.1910 CAT 372

Louis de Kerstratt, Roffy the poet, La Torrie, mathematician and aviator. Other
good friends in the Quarter were E.A. Taylor and Jessie King, who made a link
with the Glasgow School. We used to meet round the corner table at Boudet's
restaurant . . . When we couldn't pay we did our signed and dated portraits on
the back of the bill. After dinner, we went to L'Avenue for coffee and music.[14]

Fergusson's most significant relationship during the pre-war years was with
the Irish-American painter, Anne Estelle Rice (1877–1959). They met at
Paris Plage in 1907 and this encounter may well have contributed to his
decision to leave Edinburgh. For the next six years, they were closely involved,
both on a creative and personal level.

Rice was born in Pennsylvania and grew up in Pottstown, an industrial
town on the Philadelphia railroad line. Showing a strength of character and
determination not dissimilar to Fergusson, she successfully completed an art
college degree in 1897, despite parental disapproval. Initially, she worked as
an illustrator, providing work for several mainstream publications, including
Harper's Bazaar. Late in 1905, her employer, Rodman Wanamaker, the owner

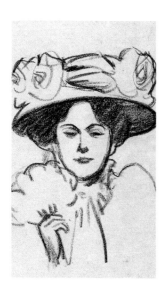
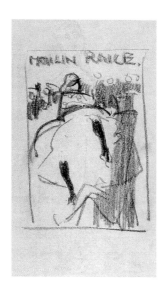

14 *Woman in Hat with Fan,*
 c.1909 CAT 366

15 Poster Design: *Moulin*
 Rouge, c.1912 CAT 361

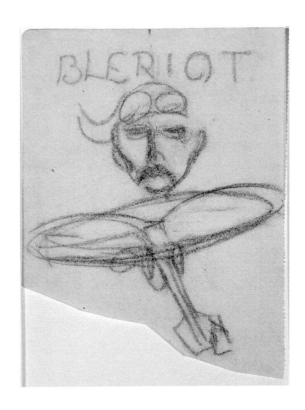

16 *Blériot,* 1909 CAT 220

17 *Blériot,* 1909 CAT 219

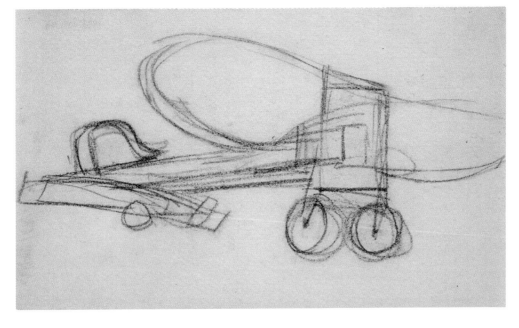

of a large department store, sent her to Paris to illustrate the latest fashions for his trade magazine. She went with a friend, Elizabeth Dryden, who was employed to write the accompanying reviews. It was through this same connection that Fergusson, albeit briefly, had come to provide designs for the same magazine.

Rice's vivacious personality provided a good match for Fergusson. She shared his curiosity and love of adventure, breaking with social convention in order to accompany him to venues that were then considered unacceptable for women. Over the next few years Fergusson painted Rice on many occasions and something of her spirited, self-confidence is captured by the pose in one of the first of these, *The White Ruff* (PL 64 CAT 43).

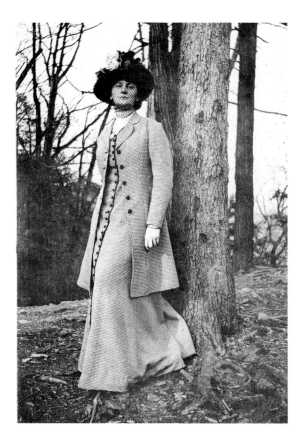

Anne Estelle Rice, c.1910

18 *The Square Hat,*
c.1910 CAT 259

19 *Salon du Mariage,*
1909 CAT 373

Stylistically, this work again recalls Whistler but the dramatic changes engendered by his move to Paris are striking when comparison is made with *Le Manteau Chinois* (PL 68 CAT 51), another portrait which he painted just two years later. Although similarly ambitious in format and scale, the anti-naturalistic green shadows on the face, bold outlining in blue and red, and generally exuberant colour indicate exciting new departures. The decorative treatment of the background serves to complement the sitter, finding a Scottish precedent in the work of Glasgow Boys, such as E.A. Hornel who typically depicted women against backdrops of flowers and foliage. It was, above all, Fergusson's ability to synthesise successfully these two strands of influence through his strong personal vision which gave his work its distinct Franco-Scottish character.

Many of the Fauves had shown similarly titled portraits at the two Paris salons and the fashion for including oriental motifs appealed to Fergusson's innate love of colourful, exotic subject-matter, leading him to paint a series on this theme. Fergusson's great admiration for Matisse, the leader of the Fauves, is apparent in his review of the 1909 Autumn Salon that was published in *Art News*. In it he observed, '. . . those in sympathy with this Salon are "Matisseites". M. Matisse is certainly one of the most interesting painters in the Salon . . . Probably M. Van Dongen, next to M. Matisse is the painter who annoys the bourgeois most'.[15]

Consistent features of Fergusson's Fauvist style are his use of dark red and blue to outline subject matter, the introduction of selected areas of bright colour, an emphasis on flat, strong pattern to enhance mood and an apparently casual placing of individual brushstrokes. In general, he avoided the most radical extremes associated with the style. His palette, for instance, tended to be much more muted, while his focus on the substance of thick, fluid oil paint contrasted markedly with the Fauves' tendency to apply pigment sparsely, leaving areas of the primed canvas exposed. As a result, the artists to whom his work generally comes closest were the more marginal figures, such as Friesz, Albert Marquet, Charles Camoin and in particular

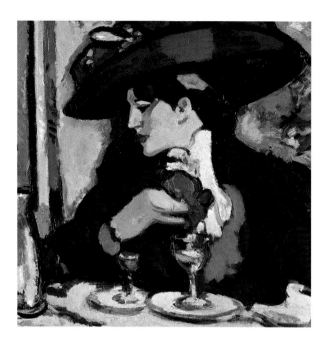

20 *The Blue Hat: Closerie des Lilas*, 1909
oil on canvas
762 mm x 762 mm
EDINBURGH CITY
COUNCIL

21 Study for *The Blue Hat: Closerie des Lilas*, c.1909 CAT 221

Auguste Chabaud. The latter, a poet-painter, used flat colour bordered dramatically by thick, dark outlines. Fergusson was attracted by the power and simplicity of his treatment and works such as *Still Life: Teapot, Flowers and Fruit* (PL 118 CAT 63) demonstrate the bold effects characteristic of this approach, even when on a small scale.

Fergusson's artistic confidence and ambition reached an all-time high in 1909 when he was elected a sociétaire of the Salon d'Automne and given an entire wall for his exhibits. *Le Manteau Chinois* was one of the six paintings he showed that year. Rice too was elected a sociétaire the following year and her painting *Danseuses Egyptiennes* (1910) was hung in the Place D'Honneur. For Fergusson, acceptance by those he most respected was the ultimate accolade: 'To me, considering myself a revolutionary, this was a very great honour – and being based on the Glasgow School, it had the effect of confirming my feeling of independence, the greatest thing in the world, not merely in art but in everything.'[16] By referring back to the Glasgow School, Fergusson placed his

own achievement within the context of a distinctly Scottish progressive tradition, a stance over which he became particularly passionate in later life.

Fergusson's love of painting women wearing striking hats during the Paris years was wholly in keeping with his taste for exotic, colourful, subject-matter. Talking of a favourite haunt he recalled:

> *Further down the Boul Miche was the wonderful Café d'Harcourt, where they had a lively Hungarian band that used a metal tray with knives and spoons and forks on it, to reinforce, very successfully, their music. But for me the great attraction was the girl frequenters. They were chiefly girls employed by dress-makers and milliners and wore things they were working at, mostly too extreme from a practical point of view, but with that touch of daring that made them very helpful – they were a great help to me.*[17]

Fergusson frequently titled his portraits not after the sitters but after the fashionable accessories which they wore such as *The White Ruff*, *The Square Hat* and *Le Manteau Chinois*. Significant links with the world of fashion came via his friendships with Anne Estelle Rice and Elizabeth Dryden, both of whom he painted frequently between 1907 and 1910. One particularly dramatic portrait of Dryden, *The Hat with the Pink Scarf* (PL 66 CAT 42)

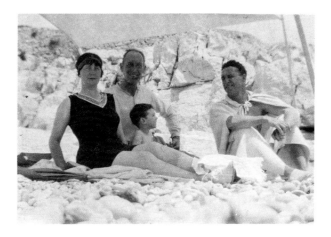

Rice, Peploe, Willy
Peploe and Fergusson,
Cassis, 1913

22 *Margaret and Willy
Peploe*, c.1911 CAT 355

23 *Margaret and Willy
Peploe*, c.1911 CAT 355

exploits rich impasto effects combined with expressive brushwork. In addition to these sitters, a further connection with contemporary fashion was forged via Yvonne de Kerstratt, the first wife of the American sculptor Jo Davidson. She owned a haute couture business near the Champs-Elysées and became another of Fergusson's regular sitters at this time. His sketchbooks contain a preparatory study for his well-known painting of her, *The Blue Hat: Closerie des Lilas*. With the exception of his self-portraits, he was to focus almost exclusively on female sitters from 1907 onwards.

In both 1909 and 1910 Fergusson, Peploe and Rice spent summer holidays together painting in Royan and nearby Saintonge, on the west coast of France. The sea and harbour inspired a number of small paintings made outdoors, which make use of stronger colour to heighten the emotional impact and mood of the scene. Many were painted at twilight, in keeping with the Paris pictures of these years. Others, meanwhile, indicate a tighter, more structured organisation of composition, a feature which became more pronounced over the years to come.

Peploe followed Fergusson's move to Paris in 1910 and was welcomed there eagerly by his friend. Fergusson recorded: 'I was very happy, for I felt that at last he was in a suitable milieu, something more sympathetic than the RSA. He was working hard, and changed from blacks and greys to colour and design. We were together again, seeing things together instead of writing about them'.[18]

In contrast to the *joie de vivre* and sensuality underlying so much of Fergusson's work, early photographs capture a somewhat forbidding steely gaze and uncompromising expression. They convey an impression of intensity and seriousness which is echoed by his numerous self-portrait sketches and two striking oil paintings of 1907 (PL 65 CAT 41) and 1909 (PL 67 CAT 52) respectively. His neat, well-groomed personal appearance is equally at odds with the stereotypical image of the bohemian artist. These inconsistencies did not escape his contemporaries such as the editor and critic

24 *Self Portrait*, c.1910
CAT 244

Holbrook Jackson, who remarked, 'Fergusson did not look like an artist. There is a strength and gravity about him which suggest the keener type of surgeon, anyhow something scientific, and this fits in with the wholehearted deliberation of his life.'[19] Jackson was equally impressed by Fergusson's immaculately kept surroundings in the rue Notre Dame des Champs, where he moved in 1909:

> *Entering his studio was like entering a new world. There was an atmosphere of almost scientific cleanliness; a complete absence of studio stuffiness and the paraphernalia of Bohemianism; no bric-a-brac, no dusty draperies. The big windows were open, the large, bare, blue-white walls caught and distributed the light and on a small white table there was a dark bowl full to the brim, not of flowers, but of those peculiarly shrill pink matchstalks which were at that time a common object of the Parisian café table. Fergusson evidently liked that colour and he just put them there. In the midst of this austerity the paintings beaconed out with the living magic of clean colour.*[20]

These revealing insights suggest that a fundamental discipline and clear-headed approach underpinned Fergusson's working methods. The physical order he imposed on his environment and his careful planning and organisation, it seems, acted as an important counterbalance to the passionate, sensual side of his temperament. This underlying stability enabled him to draw selectively from the myriad of influences around him without being overwhelmed by them and the fact that his responses were measured in this respect, allowed his personal vision to remain strong. His capacity for self-discipline was also matched by an equal measure of intellectual rigour. Nowhere was this to be better demonstrated than by the canvases that Fergusson painted over the next three years, in which he introduced the female nude, as grand in scale as it was to be in both concept and design.

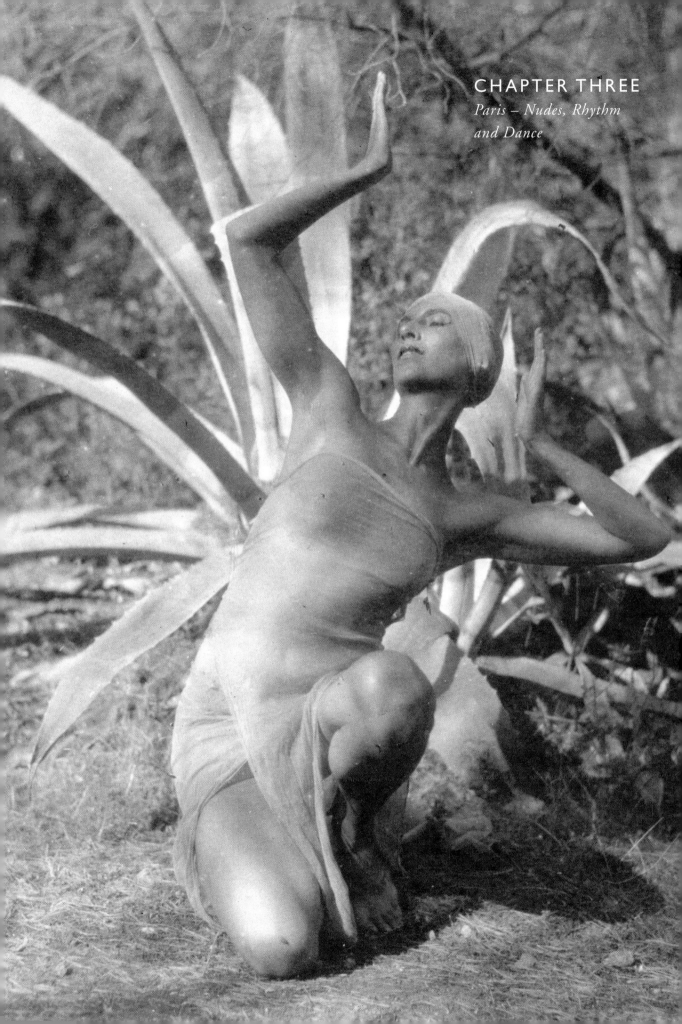

The nude remained central to Fergusson's output for the rest of his career. In this respect he differed from his fellow Colourists, none of whom tackled the subject beyond art college. For the Fauves, the nude was a standard theme and Fergusson would have been conscious of recent controversial examples such as Matisse's *Blue Nude* (1907) and Derain's *Three Bathers* (1907). Awareness of their work encouraged Fergusson's ambitious experiments. Both the size and the treatment of *At My Studio Window* (PL 77 CAT 55) suggest the significance which Fergusson attached to the departure. It was to be the first of a remarkable series of monumental nudes, which culminated with the painting *Les Eus* (PL 25). The largest canvas Fergusson ever painted, *Les Eus* is a hedonistic portrayal of earthly paradise, in which a ring of male and female nudes dance rhythmically, amongst lush vegetation.

Unlike his earlier portraits where the focus is on a specific individual, the nude in *At My Studio Window* is generalised and anonymous, hinting that she is merely the chosen vehicle through which to convey deeper, symbolic meaning. The heavily worked, and in places laboured, quality of paint suggests that much time was invested in it, possibly as a result of Fergusson's intellectual ambitions. Interestingly, this was probably the only point in his career when he employed professional models. *Woman on a Balcony* (PL 104 CAT 53), a small oil sketch of a clothed figure, clearly acted as a preparatory study for the final canvas. In the nude, a sense of mystery and remoteness is heightened by the model's dark eyes. Her face lowered and cast into strong shadow is simplified and mask-like. The robust curves of her figure, carved out by heavy, incisive outline, have been designed to accentuate fertility and regenerative power, while bright colour emphasises the mood of vitality and celebration.

Although both theme and treatment clearly demonstrate the ongoing influence of the Fauves, Fergusson's interests were not confined to the visual arts. In the case of his portrayals of the nude, the philosophy of Henri-Louis Bergson (1859–1941) was critical. Bergson's view of a feminine principle of life force, the *élan-vital*, held particular potency. He was the most celebrated

thinker of the day and his popularity peaked in Paris in 1907, following the publication of his book, *Creative Evolution* (1906), which coincided with Fergusson's arrival in the city. Many artists became ardent supporters of Bergson's theories due to the fact that he referred to aesthetic and artistic examples when explaining his theories. His stress on key terms such as 'life-drive', 'creativity', 'intuition' and most significantly in Fergusson's case, 'rhythm', held a special resonance.

Through Fergusson's ever widening social circles and the lively debate of café conversation, he would certainly have been familiar with the basic

25 *Les Eus*, c.1911–13
oil on canvas
2133 mm x 2743 mm
UNIVERSITY OF
GLASGOW, HUNTERIAN
ART GALLERY

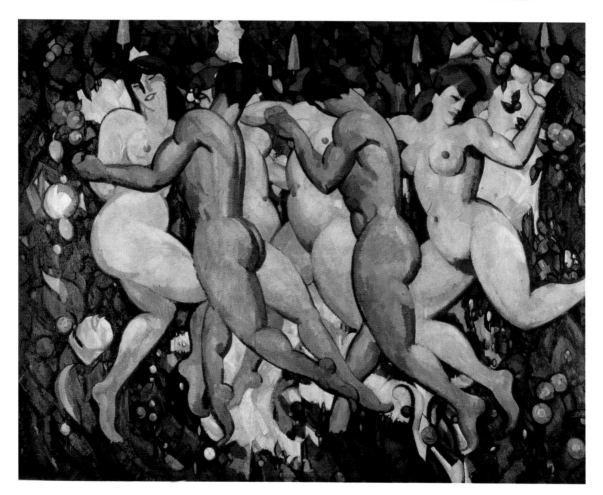

principles of Bergsonism. Furthermore, his interests in 'rhythm' are recounted in detail in the autobiography of the English literary critic, John Middleton Murry. Murry's initial visits to Paris were made as an Oxford undergraduate to hear lectures given by Bergson. Whilst continuing his studies in Oxford, he began to develop the idea of creating an innovative art journal, aimed at spreading the philosopher's theories. He met Fergusson purely by chance in the Café d'Harcourt in the winter of 1910 and was immediately and profoundly affected by this encounter. This was due as much to the strength of Fergusson's character and his physical presence, as by his recognition amongst the Parisian avant garde. An immediate rapport was established between the two, for their initial meeting ended with Fergusson inviting Murry to his studio, in order to explain the links which he believed existed between his work and Bergson's philosophy. Talking of their early contact Murry later recalled, 'One word was recurrent in all our strange discussions – the word "rhythm". We never made any attempt to define it; nor ever took any precaution to discover whether it had the same significance for us both. All that mattered was that it had some meaning for each of us. Assuredly it was a very potent word.'[21]

It was precisely the lack of any exact definition for the term 'rhythm' which enabled it to be adapted to a wide range of possible meanings and purposes. The widespread interest in the interdisciplinary nature of the arts before the First World War was central to Fergusson's preoccupation with the term and caused Murry to reach the following conclusion:

For Fergusson it (rhythm) was the essential quality in a painting or sculpture; and since it was at that moment that the Russian Ballet first came to Western Europe for a season at the Châtelet, dancing was obviously linked, by rhythm, with the plastic arts. From that, it was but a short step to the position that rhythm was the distinctive element in all the arts, and that the real purpose of 'this modern movement' – a phrase frequent on Fergusson's lips – was to reassert the pre-eminence of rhythm.[22]

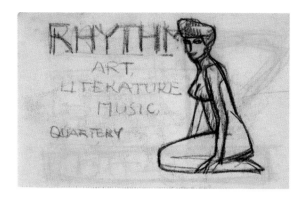

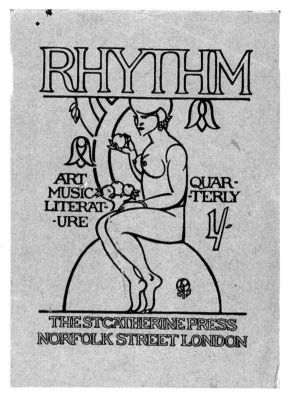

26 Cover Design for
Rhythm Art Jounal,
1911 CAT 269

Rhythm Journal, 1911
FERGUSSON ARCHIVE

It was not surprising, given Fergusson's seniority and established reputation, that Murry and his friend, Michael Sadler enlisted his help in launching their proposed publication. They realised that his input as Art Editor would add credibility and authority to their new venture and for this reason he came to play an instrumental role in the journal's origination as well as its subsequent content. According to Fergusson's notes, he initially suggested calling it *The Quest*, or something similar, and this is borne out by his preliminary sketches for the cover design. Murry and Sadler, however, preferred *Rhythm* (PL 26 CAT 269) and this was the title they ultimately adopted. According to Fergusson, they chose the name having seen his painting *Rhythm* (PL 27) on show at the 1911 Salon d'Automne. However, this exhibition took place after the publication of the first edition of the journal, in the summer of 1911. As

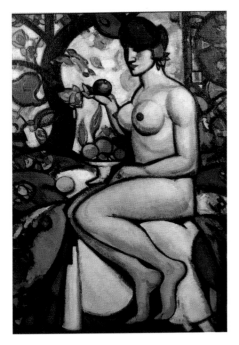

27 *Rhythm*, 1910
 oil on canvas
 1162 mm x 1155 mm
 UNIVERSITY OF STIRLING

28 *Étude de Rhythm*,
 1910 CAT 59

a result, there are two possible alternative scenarios. Either that the cover design for the journal actually formed the basis for the large oil painting, or Murry and Sadler saw the work in progress in Fergusson's studio before it went on display at the salon. He had also exhibited an earlier semi-abstract picture titled *Étude de Rhythm* (PL 28 CAT 59) at the Salon des Indépendants in the spring of 1911, and this may even have been the work from which they drew their inspiration.[23]

Despite the confusion surrounding the origins of *Rhythm* journal, there is little doubt that Fergusson made a significant contribution as Art Editor, securing illustrations from an international array of contributors. The chief artistic input, perhaps not surprisingly, was drawn from his immediate circle of friends. Rice, Jessica Dismorr, Dorothy Banks, Marguerite Thompson, Peploe and Fergusson himself provided head and tail piece designs, as well as the occasional drawing or painting. In 1912, this group of Anglo-American artists exhibited together at the Stafford Galleries in London, where the critic, P.G. Konody hailed Fergusson and Peploe as the leaders of a distinct trend within French Post-Impressionism. Other critics wondered why these artists were excluded from Roger Fry's concurrent, Second Post-Impressionist Exhibition at the Grafton Galleries, a ground-breaking show which did much to shape subsequent opinion and writing on British art. Other contributions to *Rhythm* were secured from artists then little known, who have subsequently become established as the leaders of twentieth-century modern art. These included: Picasso, Gaudier Brezska and the Russian Constructivists, Natalia Goncharova and Mikhail Larionov. Many of the Fauves were also involved, such as Derain, Friesz, Manguin, Marquet and Dunoyer de Segonzac.

The literary content of the magazine reflected contemporary issues, stressing both the interdependence of the arts and, as was implicit in its title, the links between them and Bergson's theories. Whilst the quality of the art work varied considerably, *Rhythm*'s role was significant, giving the British public their first opportunity to see reproductions of this kind in a magazine form. The variety of contributors alone demonstrates the impressive breadth

29 *Woman Seated at Bar*, illustrated in *Rhythm*, c.1912 CAT 294

Cover design for
Katherine Mansfield's
Prélude
FERGUSSON ARCHIVE

of Fergusson's artistic contacts at the time. From the outset, it was the intention to keep the journal as affordable as possible. As a result, the artists adopted a simple style to achieve the maximum effect with the minimum means. Using block printing, they achieved stark, dramatic images by exploiting black and white contrasts. Fourteen editions of *Rhythm* were published between 1911 and 1913, the venture eventually folding due to increasing funding difficulties.

Fergusson met the New Zealand author Katherine Mansfield in 1911, when she became Murry's co-editor on the literary side of *Rhythm*. Murry and Mansfield married in 1918 and Fergusson and the artist Dorothy Brett acted as witnesses at their wedding. In the same year, Mansfield invited Fergusson to provide illustrations for her book, *Prélude*, which was published by Leonard and Virginia Woolfs' Hogarth Press. Apparently the Woolfs took a strong dislike to Fergusson's woodcuts and printed only half a dozen copies including his designs.

During the Rhythm years, music and dance were particularly topical. The early 1900s began a revival of interest, focusing on the American dancer

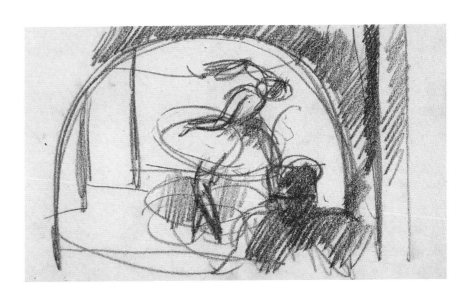

30 *Russian Ballet: Stage Set*, c.1910 CAT 359

Isadora Duncan. Her accent on natural, simple movement provided a freer interpretation of the expressive potential of dance, contrasting dramatically with the classical ballet. Her work was closely related to the pioneering theories of Émile Jaques-Dalcroze, whose influential philosophy of eurythmics introduced a radical new science of dance linked with health around 1910. Most significant of all, however, was Serge Diaghilev's Russian Ballet tour in Paris between 1909 and 1914. Staged on a spectacular scale, the performances created an immediate sensation and were to exert a huge influence on artists. Drawing on the combined talents of musicians, dancers, set and costume designers, the performances created a powerful example of what could be achieved through collaboration. By doing so, it did much to foster and encourage the appreciation of the links between the arts. As sociétaires of the Salon d'Automne, Fergusson, Rice and Peploe enjoyed the privilege of free seats at these performances, many of which were recorded in the pages of Fergusson's sketchbooks. His experiences left a profound impression, causing him to remark:

> We were all very excited with the Russian Ballet when it came to Paris. Bakst was a sociétaire of the Salon d'Automne and used all the ideas of modern painting for its décor. Diaghilev made a triumph, surely even greater than he had hoped for. No wonder S.J. [Peploe] said these were some of the greatest nights of his life. They were the greatest nights in anyone's life – Schéhérazade, Petruchka, Sacre du Printemps, Nijinski, Karsavina, Fokine.[24]

Fergusson was probably first introduced to the Russian Ballet via his friendship with Dunoyer de Segonzac, whose interests in dance were evident in the publication of two volumes of his drawings in 1910; *Schéhérazade: 24 Drawings of a Russian Ballet* and *Isadora Duncan*. Fergusson's interests in design, rekindled by his involvement with *Rhythm* art journal, received fresh impetus in 1913 when he contributed to Francis Carco's *Chansons Aigres-Douces*, with Dunoyer de Segonzac and Luc-Albert Moreau.

31 *Russian Ballet:*
Harlequin, c.1911
CAT 354

32 *Margaret Morris on*
Stage, Paris, 1913
CAT 295

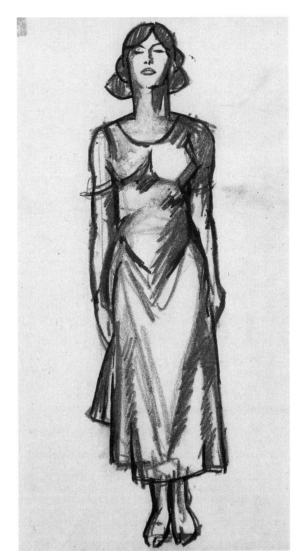

The revitalisation of interest in dance in Paris was one strand of influence that carried particular personal significance for Fergusson. Amongst those it attracted was Margaret Morris (1891–1980). She came to perform there with a group of her pupils in spring 1913, at the Marigny Theatre. Now regarded as one of the pioneers of modern dance in Britain, she learnt classical Greek movement with Raymond Duncan, brother of the famous Isadora, and came to use this method as the basis for her own training methods. Within two years, at the age of 19, she had established her own dance school in Chelsea, with the financial backing of the playwright John Galsworthy. In keeping with early twentieth-century trends, the training methods that she subsequently developed aimed at achieving freer modes of expression.

It was through their mutual acquaintance with Holbrook Jackson that Morris and Fergusson met, thus beginning a lifelong relationship of great consequence. Her dynamic personality and sensuous physicality captivated Fergusson, inspiring much of his subsequent work. Despite her undoubted importance as Fergusson's model, however, this aspect was secondary to the development of a mutually beneficial creative partnership. Their relationship, not least, strengthened and sustained a shared belief in the interdependence of the arts. Fergusson did what he could in Paris to forge useful contacts for Morris but soon after she had to return to London to resume her work commitments. She and Fergusson wrote frequently to each other over the coming months.

After the demolition of his Paris studio later in 1913, Fergusson decided to set off in search of 'more sun, more colour'. Following in the footsteps of the Fauves, he explored the coastline on the South of France. The summer was spent with Peploe and Rice in Cassis, where he worked outdoors painting landscapes of great freshness and immediacy such as *Cassis* (PL 113 CAT 65) and townscapes such as *Cassis from the West* (PL 112 CAT 66) which shows Cézanne's influence. Fergusson's stylistic debt to this artistic giant was to grow ever more prominent over the years to come.

Although Fergusson and Rice were to remain friends for the rest of

Cassis, c.1913

their lives, Morris's arrival appears to have ended their romance and Rice's letters of this date suggest the deep personal unhappiness that this parting caused her. Soon after, however, Rice was to marry an English writer and critic, O. Raymond Drey.

Fergusson eventually settled in a small villa in Cap d'Antibes, then a remote, beauty spot. Here he was to respond with renewed excitement and vigour to the intense and clear quality of light, which had likewise impressed the Fauves. In a letter to Morris of 6 December he wrote:

> *The place here has given me quite a new start, a different feeling altogether about painting, or rather it has given me what I've been trying to make out of nothing – the colour, the shapes, everything that I was developing by sheer sweat and labour is here. The light that one snatched with excitement when it happened once in a blue moon, is here even in winter.*[25]

OPPOSITE

Margaret Morris wearing Fergusson's hand-painted costume for her ballet *Spring*, 1914

By the Christmas of 1913 he had persuaded Morris to join him, for what was to be an idyllic holiday. Back in London, Morris began work on a ballet inspired by Stravinsky's music which she titled *Spring*. Fergusson wrote to her from Antibes, enclosing numerous sketches for costume designs and detailed

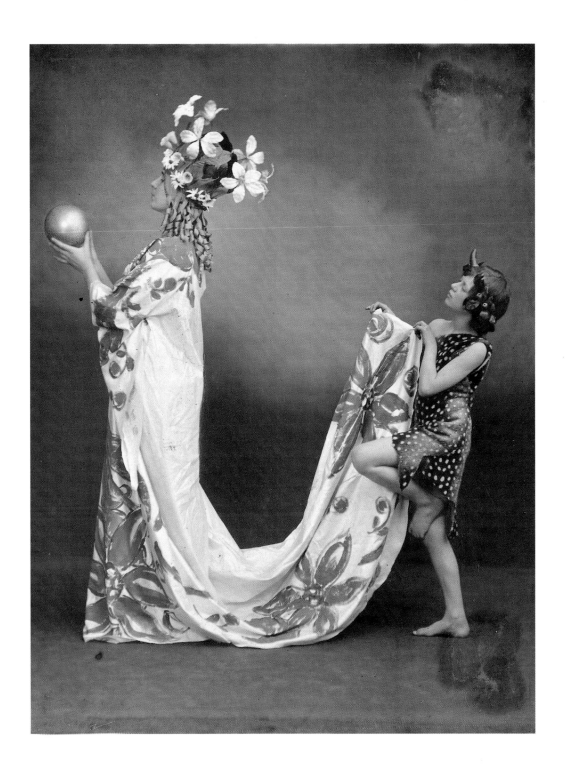

33 *Design for Spring
 Ballet: Star Flower,*
 1914 CAT 385

34 *Design for Spring
 Ballet: Morris's Cloak,*
 1914 CAT 385

descriptions of how he envisaged the performance, whilst also advising her on her own designs.

> *I just managed to finish the colour of the designs tonight before the light went, it's light now until seven. I worked yesterday and all today on them . . . What weather this evening after I'd finished – I went out and watered the flowers – they deserved it having sat for the designs. The main design and the earth background one, are from the Girofle in the garden; another of these beautiful "star" flowers has appeared out on the grass. My cherry tree is really a joy, I painted it in my sketch last night. Leaves are coming out on the fig tree – the fig came first, oddly enough. Everything is wonderful . . .*
>
> *To sum up the different things – first the white flower, star-shaped, that's to say, expanding in all directions, chiefly upward: the longest petal expressing the coolness and cleanness of Spring. Then, your cloak, the leaves of it as in the light realistic drawing, long leaves allowing the swing and movement of the Spring wind – and your dancing should be that shape [drawing], but the kids, all angles expressing the straining from one side to the other and upward of the things from the earth . . .*
>
> *Of course there are thousands of other things, but roughly that's my idea, which is entirely from my experience of this Spring here, and what I have been painting and observing all the time.*[26]

Morris joined Fergusson in the South of France again the following summer and later recalled with great nostalgia:

> *. . . the wonder of the summer at the Cap d'Antibes passes all description. Fergus had everything organised, a good supply of charcoal for slow cooking, omelettes and soups. He had hung a hammock on the fig tree, so one could lie in it and pull the ripe figs – sometimes the early ones dropped on one, overripe! I remember standing on the tiny balcony and saying to myself – nothing can ever be as perfect as this . . . We had many amazing summers later with wonderful*

35 Study for *Summer
1914*, 1914 CAT 302

36 *Summer 1914*, 1934
CAT 107

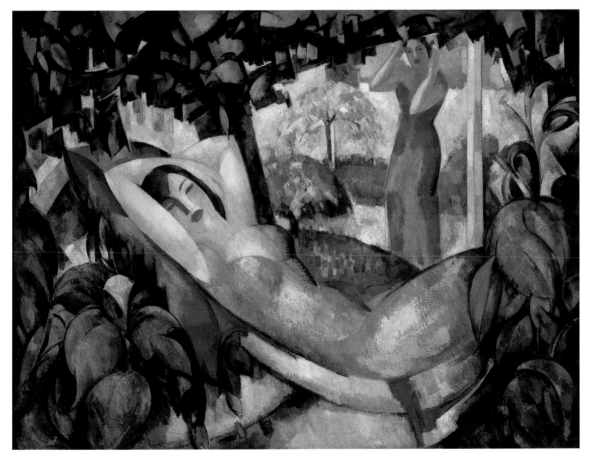

friends on the Cap, but none could ever touch that complete isolation and communion on every plane that we enjoyed then.[27]

A visual equivalent to her description is provided by Fergusson's painting *Summer 1914* (PL 36 CAT 107), in which she reclines in the hammock overhung with rich foliage. The canvas reveals much about Fergusson's working methods, as it was painted 20 years after the event in 1934, using original sketches combined with his memories of this unforgettable experience. The outbreak of the First World War was to shatter the perfection of their existence, causing Morris to return reluctantly to London. Fergusson was to follow soon after.

Fergusson's artistic course was radically altered by Germany's declaration of war on France in August 1914. From this point onwards he never fully regained the momentum of the Paris years. His subsequent career was largely a time of consolidation, focusing on the reworking of existing themes and ideas but it was not entirely without fresh departures. Equally remarkable was the lifestyle that he and Morris enjoyed and which continued to provide a range of stimulating social encounters.

The period began on a promising note for Fergusson with a solo exhibition at the Doré Galleries in New Bond Street, London. The foreword to his exhibition catalogue was written by Frank Rutter, the critic who had championed his work and that of fellow Rhythmists at the Stafford Galleries two years before, who stated:

> *Mr Fergusson is already regarded as a 'chef d'école', and the recognition his art has already received in Germany and the United States, as well as in France, should contribute to his honour in his own country . . . A born colourist and fastidious to preserve purity as well as harmony in his paint, he charms us not only by the beauty of his colour, but also by the exquisite rhythm of his design.*[28]

Fergusson's choice of London as his base undoubtedly reflected his desire to be near Margaret Morris, although for the sake of respectability they lived separately for many years to come. Fergusson eventually took permanent lodgings in a studio flat at 14 Redcliffe Road in Chelsea. Morris's role was to be vital to his subsequent artistic development, as was her financial support over the next few years. Her work provided a critical focus for his own, not least because she and her pupils became his most frequent source of artistic inspiration. In return, Fergusson gave art lessons at her school and became even more deeply involved with the design of stage sets, costumes and lighting for her performances. In terms of her approach, Morris freely acknowledged a debt to him.

PREVIOUS PAGE
Fergusson with his sculpture, *The Patient Woman*, c.1930

I first realised the absolute necessity of relating movement with form and colour when studying painting of the modern movement in Paris in 1913. From that time I incorporated it as one of the main studies in my school. In this connection I am deeply indebted to J.D. Fergusson the painter, who for years has taught the painting, design and sculpture in my school and who first made me realise the possibilities of theatrical work considered from the visual point of view and the value of the study of form and colour as a means of education.[29]

Significantly for Fergusson, Morris held a weekly club at her modest theatre premises. Many leading figures of the British avant garde attended, including Augustus John, Jacob Epstein, Wyndham Lewis, Arnold Bax, Ezra Pound and the Sitwell and Goossens families. Contact with this mix of artists, writers and musicians provided some sense of continuity with the lively atmosphere he had enjoyed in the Paris cafés. The bohemian lifestyle into which Fergusson had by then settled and his taste for themes tinged with exoticism continued to an extent within this new environment. A preparatory study for the oil painting *Rose Rhythm* (Private Collection, 1916, oil on canvas, 508 mm x 508 mm), for instance, clearly demonstrates links with Fergusson's pre-war ideas. He outlined the development in the following passage:

When I came back to London at the beginning of the First World War in 1914, I met one of Margaret Morris's best pupils, Kathleen Dillon, a very good-looking, charming and intelligent girl . . . one day she arrived with a remarkable hat . . . It was just like a rose, going from the centre convolution and continuing the 'Rhythm' idea developed in Paris and still with me. Looking at Kathleen I soon saw that the hat was not merely a hat, but a continuation of the girl's character, her mouth, her nostril, the curl of her hair – the whole character – like Burns's love is like a red, red rose . . . At last this was my statement of a thing thoroughly Celtic.[30]

37 Study for *Rose Rhythm*, 1916 CAT 304

Other regular attenders at Morris's club included John Middleton Murry and

Katherine Mansfield, renewing personal contacts established during the *Rhythm* years in Paris. Fergusson dined weekly with them at their house, which was opposite his on Redcliffe Road. Mansfield's letters of the time reveal her special affection for him:

> *I came home this afternoon and Fergusson came in. I was standing in the studio, someone whistled on the path. It was he. I went out and bought some milk and honey and Veda bread. By and by we sat down and had tea and talk. This man is in so many ways extraordinarily like me. I like him so much, I feel so honest with him that it's simply one of my real joys, one of the real joys of my life, to have him come and talk and be with me. I did not realise, until he was here and we ate together, how much I cared for him – and how much I was really at home with him. A real understanding.*[31]

The club also forged new friendships of significance, most notably with the Glasgow architect and designer Charles Rennie Mackintosh and his wife Margaret Macdonald, who had moved to London by the summer of 1915. Fergusson had long admired Mackintosh's work and strongly sympathised with his decision to move to the South of France in 1923. This move was largely due to the general lack of recognition Mackintosh had experienced in Scotland. It may even be that Fergusson recommended the location to him, based on his personal knowledge of the area.

In 1918 Fergusson and Mackintosh joined forces with a number of influential contemporaries in an attempt to recreate the enlightened atmosphere of pre-war Paris. Their aim was to establish a London version of the Salon des Indépendants, an initiative first attempted by Rutter in 1908 through his founding of the Allied Artists' Association. The cover of the 1918 prospectus lists the management committee amongst whom were the sculptor Frank Dobson and the painter Charles Ginner as well as Rutter. Fergusson and Mackintosh suggested adapting glass-roofed army huts in Hyde Park to provide the necessary hanging space, but their idea was refused and as no

Cover of *London Salon of the Independants*, 1918
FERGUSSON ARCHIVE

other suitable venue could be found, they were forced to abandon their efforts. Similar misfortune surrounded Mackintosh's adventurous designs for a theatre with a pseudo-Egyptian façade for Margaret Morris in 1920 and also a project for a block of artists' studios and flats, sponsored by the Arts League of Service, with which Fergusson had been closely involved. Both projects were ultimately left unrealised due to lack of capital.

During the summers of 1915 and 1917 Fergusson made extended trips to his family home, which was now situated in Bonnyrigg on the outskirts of Edinburgh. He used the opportunity to visit Peploe and another close friend, the author and businessman, John Ressich. Although Fergusson's artistic pace lessened considerably during the war, he did continue to paint. The intense watercolour study of *A Lowland Church* (PL 38 CAT 180), depicts a now demolished building of distinctive design at Lasswade. The closely related final oil painting shares with the study the same desire to create an illusion of volume.

In keeping with this development, Fergusson also embarked on a new venture – sculpture – initially devoting time to a number of stone carvings of heads in his mother's garden. The origins of his sculptural tendencies can be

38 Study for *A Lowland Church*, 1914 CAT 180

39 *A Lowland Church*, 1916
oil on canvas
508 mm x 559 mm
DUNDEE CITY COUNCIL

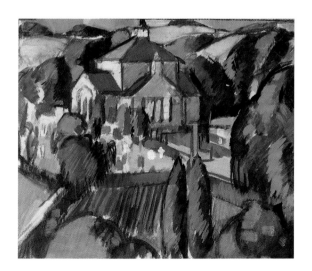

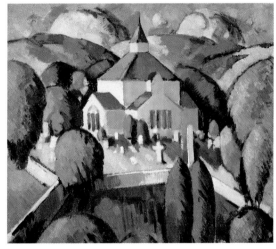

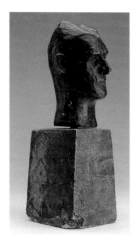

40 *Head of the Artist,*
1908 CAT 144

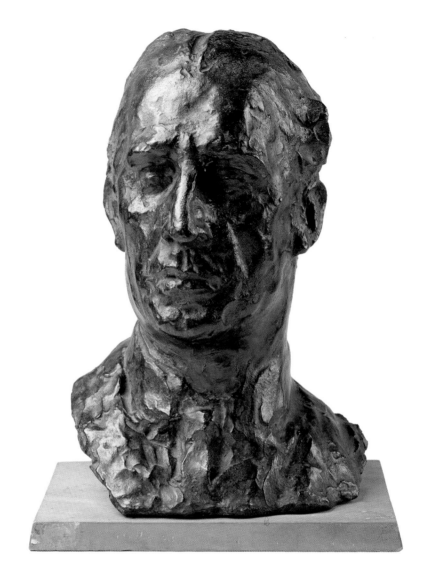

J.D. Fergusson, 1908
bronze
height: 380 mm,
by Jo Davidson

traced long before he actually began to produce works in the round. His lasting preference for layering thick, juicy paint onto canvas, expressed by him as a desire for 'solidity' and 'durability' underline a fundamentally sculptural approach. In fact, Fergusson seems to have viewed his sculpture as an integral part of his practice and this is supported by the many parallels existing between his works in two and three dimensions. The first known sculpture by Fergusson is a small self-portrait of 1908, modelled as a result of his friendship with the American sculptor Jo Davidson, whom he met in Paris. This was to be a one-off experiment at the time. Davidson, later renowned for the portrait commissions he received from Einstein, Charlie Chaplin and President Roosevelt amongst others, had modelled bronze busts of both Fergusson and Anne Estelle Rice in Paris, in the same year.

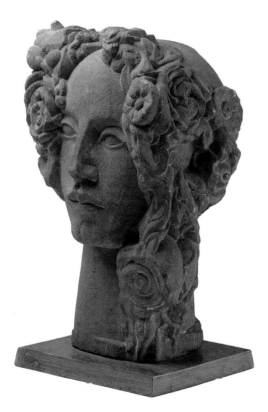

41 *Summer: Head of Woman*, 1916 CAT 148

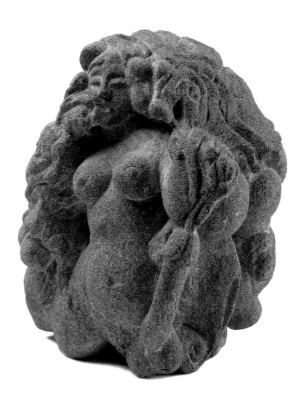

42 *Female Head and Foliage*, 1916 CAT 147

Fergusson's statuesque, robustly painted nudes of 1910–12 would appear to lend themselves naturally to a three-dimensional progression and indeed in 1912 when he exhibited at the Stafford Galleries, he showed four terracotta figurines.

Having painted Dillon in *Rose Rhythm* in London in July 1916, the following month found Fergusson in Edinburgh carving a portrait of her called *Summer*, from a rich, rose-coloured sandstone. It was above all the setting of his mother's spacious garden which encouraged his initial experiments, as one of his letters confirms, 'it's the place that makes me do it. Seeing things against the foliage'.[32]

The natural setting also inspired the symbolism of the seasons alluded to by Fergusson's title and carried through in Dillon's hair, which he portrayed as a rhythmic cascade of flowers and foliage. This treatment shares significant

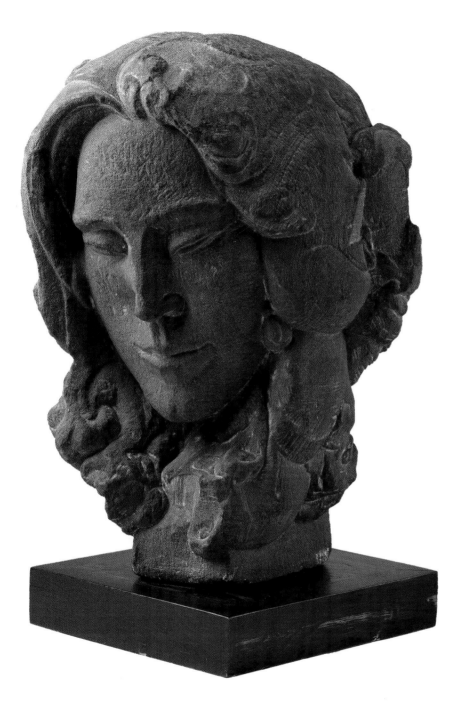

43 *Ténèbres*, 1915
CAT 145

44 *Study of an Eastern
Sculpture*, 1913
CAT 345

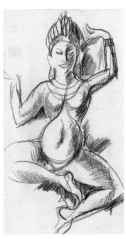

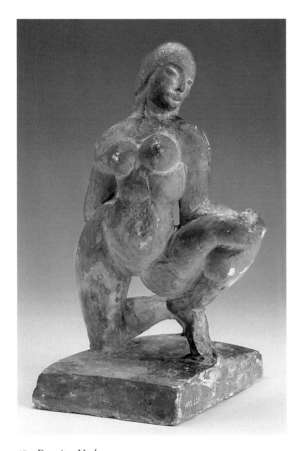

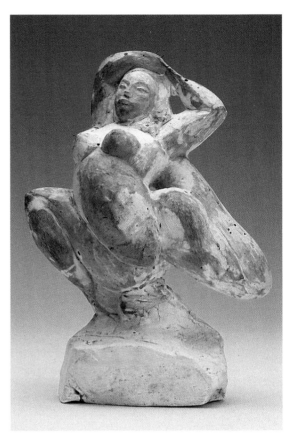

45 *Dancing Nude:*
Effulgence, c.1920
CAT 153

46 *Female Dancer*, c.1920
CAT 154

links to his paintings, as well as providing a degree of continuity with his celebratory, life-affirming pre-war nudes. Another piece, titled simply *Female Head and Foliage* (PL 42 CAT 147) is carved in deep relief on the sides of a block of pink sandstone and uses an unusually overt sexual symbolism, both female and male, to extend the theme of regenerative power.

As demonstrated by many of Fergusson's Paris sketchbooks, he had been deeply impressed by the Cambodian and Indian sculpture which he studied at the Trocadéro Museum in Paris. Several of his sculptures indicate the ongoing influence of this source. The stone head, *Ténèbres* (PL 43 CAT 145) for example, conveys a brooding exoticism through its slanting, heavily lidded

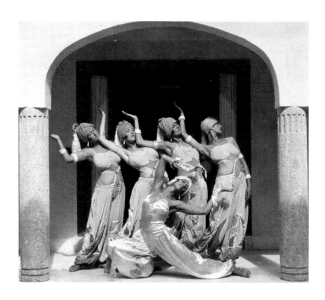

Margaret Morris and her dancers performing *Le Chant Hindu*, c.1915
FERGUSSON ARCHIVE

Margaret Morris performing *Le Chant Hindu*, c.1915
FERGUSSON ARCHIVE

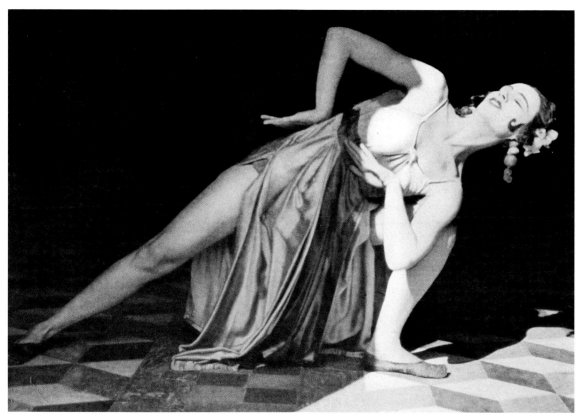

47 Study for *Torse de Femme*, 1912 CAT 278

48 *Torse de Femme*, 1918
CAT 149

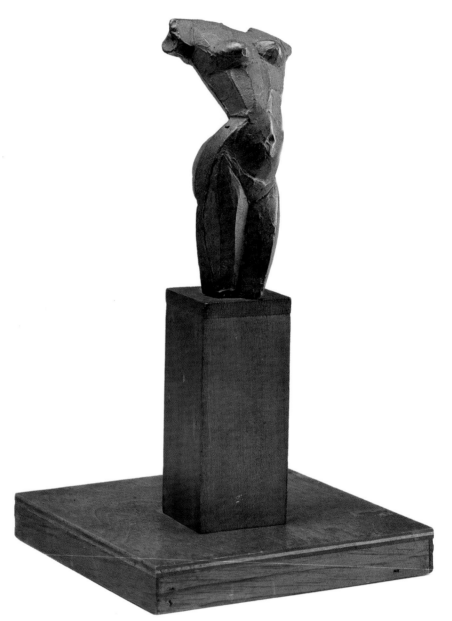

eyes, again hinting at the mysterious powers of the female sex. Further Eastern influences are found in a number of small dancing figurines in plaster which echo the rhythmic poses and firm, fertile forms of Indian temple goddesses from his sketchbooks. (PL 145–146 CAT 154–155)

It is no coincidence that these nudes also bear a close relationship to Morris's work. In particular, they echo the performances that she choreographed for Olympia in 1915, which were based on the Oriental theme of *Le Chant Hindu*, set to music by the Russian composer Rimsky Korsakov. One of the few theatre-based paintings that Fergusson ever made records Morris's performance in the lead role. The lighting and costume for the piece were stark and dramatic and similar effects are conveyed by the portrait *Margaret Morris dans Le Chant Hindu* (PL 71 CAT 70). Fergusson also cast a number of modestly scaled nudes in bronze and brass, which, despite their size, retain a sense of power and monumentality. Examples such as *Torse de Femme* (PL 48 CAT 149) and *Plénitude d'Olivier* (PL 49 CAT 151) break the female form down into taut, compact forms. This pared-down treatment was paralleled by a greater degree of geometry in his paintings. Perhaps the best known of all Fergusson's sculptures is his brass head *Eastre: Hymn to the Sun* (PL 50 CAT 165). Inspired by Morris, his intention was to create a timeless image of the so-named Saxon goddess of Spring, thus evoking the season associated with 'the triumph of the sun after the gloom of winter'. [33]

The sharp, clean lines of the piece give it a modernist edge that Fergusson achieved by incising directly into the original plaster version. Casting sculpture in brass at this date was relatively unusual, although the sculptor Frank Dobson had made a head of Sir Osbert Sitwell the previous year. Fergusson knew Dobson through Morris's club and may well have been aware of this work, but, as other pieces show, he had been experimenting with brass himself for a number of years. On this occasion the choice of material was highly symbolic, creating the effect of a glowing, golden orb. In keeping with this, he later described his intentions for the piece in the following way:

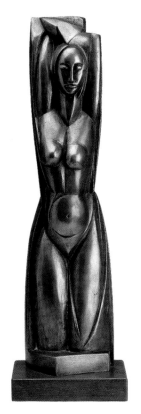

49 *Plénitude d'Olivier,* 1919 CAT 151

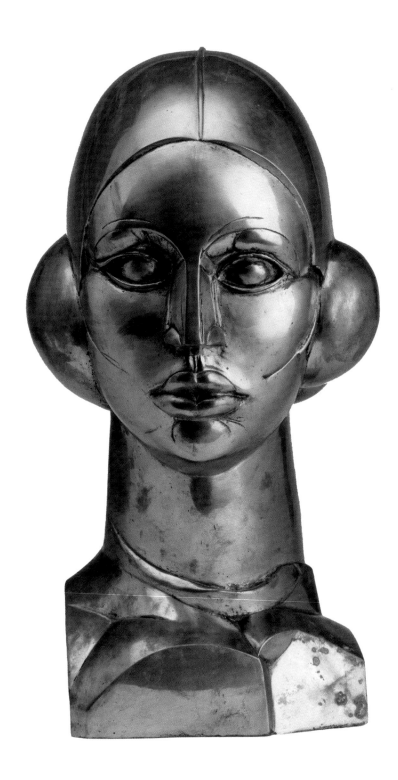

50 *Eastre: Hymn to the*
 Sun, 1924 CAT 165

The head is composed entirely of sections of a sphere – the forehead is round, the eyes are round, cheeks round, hair represented by two pads, one on each ear, half-spheres; all the same idea . . .the effect of the sun . . . (the sculptor) still has a great sympathy with Celtic sculpture, and on the Celtic crosses there are bosses – round shapes, half-spheres which express for him "Suns", fullness, open eyes, women's breasts, apples, peaches, health and overflow . . . [34]

It was not until 1918 that Fergusson was called up for military service. At 44 he was just within the age for conscription but he passed his medical with the top A1 grading. His most immediate concern, however, was the threat to his plans to hold an exhibition at the Connell Gallery in London that May, his first solo show for four years. John Middleton Murry wrote the foreword to the catalogue, while the exhibition attracted a major review in the June issue of *Colour Magazine*, featuring Fergusson's painting *Summer* on the front cover. In the event, the exhibition helped him to gain exemption from military service by giving those on the British War Memorials Committee the chance to see his work. Eventually, with support from the art critic of *The Observer*, P.G. Konody, a six-week commission was proposed by the Ministry of Information's Propaganda and Record Department. Fergusson was given access to Portsmouth Docks to make sketches and gather ideas from which to paint. He was lucky, having specifically requested a naval posting due to his lifelong passion for the sea and boats and, according to Morris, his dislike of the army's khaki-coloured uniforms. Fergusson arrived in Portsmouth at the end of July 1918 and in a series of letters written to Alfred Yockney, secretary of the British War Memorials Committee, he reveals the immediate enthusiasm which he felt for the project. He produced many conté and pastel drawings, which were later transformed into a series of distinctive studio-based paintings. In them his tendencies towards a new language of simplified geometric shapes portrayed within shallow space evolved.

It is likely that this treatment reflected Fergusson's awareness of Cubist works but also those of the Vorticists, many of whom attended Morris's club

Connell Gallery
exhibition catalogue, 1918
FERGUSSON ARCHIVE

Colour Magazine, June
1918
FERGUSSON ARCHIVE

51 *Portsmouth Docks,*
1918 CAT 306

in Chelsea and who had also exhibited in London in June 1915. Works such as *Blue Submarine: Portsmouth Harbour* (PL 115 CAT 69) illustrate a more precise, disciplined application of the paint. The technique of blocking-in areas of colour in a series of regular hatched strokes is distinctly Cézannesque. The solid, static shapes created by the moored warships in the docks, alongside cranes and other naval machinery were transformed into images of calm monumentality and dignity, far removed from the carnage and destruction of the war. The clarity of Fergusson's palette also enhanced a mood of characteristic optimism, juxtaposing cool blues and lilacs with fiery oranges and pinky-terracottas. The lively colour scheme is far from representational despite the assurances that Fergusson had given to the Ministry of Information prior to embarking on his commission. There is also a degree of artistic licence shown in terms of the accuracy of the vessels portrayed. This was in keeping with Fergusson's persistent focus on the formal values of painting, once again placing his artistic freedom above all contrary demands. On completion, the Ministry of Information selected one oil painting and four sketches for their records, but, with the end of the war and the closure of the department shortly after, the works were returned in January 1919.

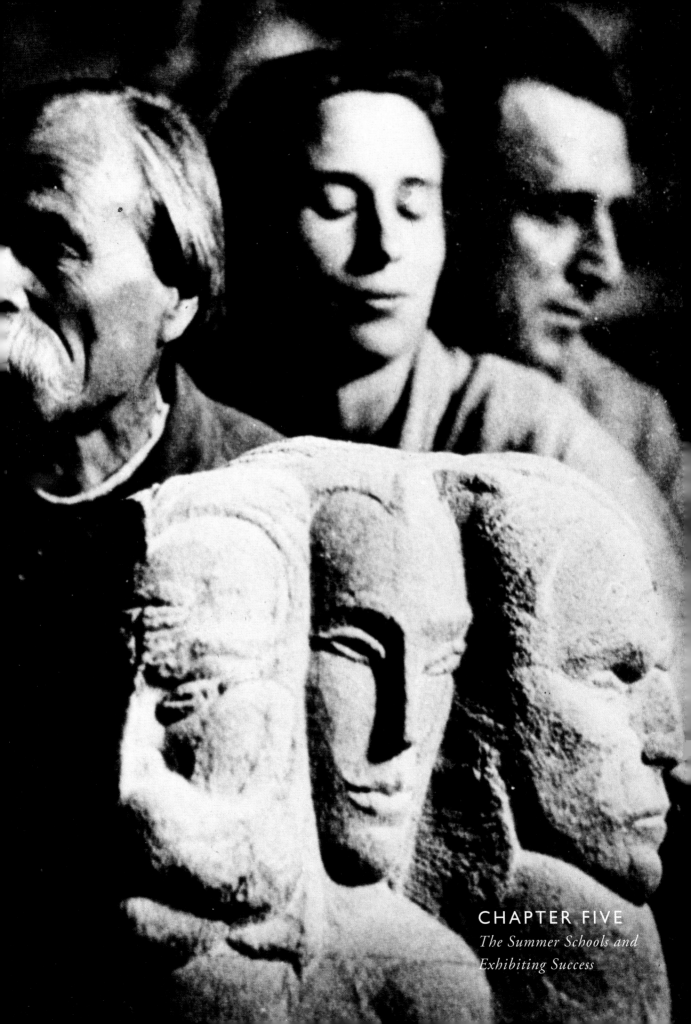

CHAPTER FIVE
The Summer Schools and
Exhibiting Success

George Davison in the
Great Hall, Wern Fawr,
Harlech, c.1920

PREVIOUS PAGE

Davison, Morris and
Fergusson with *Harlech*,
c.1920

The advent of Margaret Morris's Summer Schools in 1917 was to be of lasting significance to Fergusson's artistic development. Although now a familiar concept, Morris's idea was truly ahead of its time, reflecting her awareness of the pioneering work of Isadora Duncan and Émile Jaques-Dalcroze. As her training methods developed, she had noticed a definite improvement in her students' posture and general health. This led her to focus increasingly on the therapeutic benefits to be gained through her work. The introduction of the Summer Schools was an important sign of this shift towards a more health-centred and holistic approach.

The first two Summer Schools were held in Combe Martin in Devon but in 1919 the venue chosen was Harlech in North Wales. This in turn was eventful, providing an introduction to George Davison, a retired business-man who had built up a substantial fortune while working as a manager for Kodak. In his retirement he used his money to support those he perceived as underdogs, including nine orphaned children whom he adopted with his partner Joan. Davison was an eccentric and self-proclaimed anarchist and his circle of friends included writers, artists and political activists. His property, 'Wern Fawr', was built on a grand scale, and had extensive grounds which ran down to the sea. It was designed by the Glasgow architect George Walton for whom Davison acted as an important patron. Having been much impressed by Morris's unconventional ideas and dance technique, Davison generously offered to accommodate her Summer School in 1919 and again in 1921. During the first visit to Wern Fawr, Fergusson sculpted from a block of granite an ambitious tripartite portrait of their host, Morris and himself. According to his notes, it was a decidedly unforgiving material on which he broke many of his chisels. Now lost, *Harlech 1919*, fortunately remains in photographic records including one taken by the American photographer Alvin Langdon Coburn depicting the three sitters posing above the carving. Fergusson's sketchbooks of 1921, meanwhile, record his delight in the wild mountain goats which roamed the outcrops near the sea and which inspired a particularly memorable small sculpture, later cast in brass (PL 52 CAT 161).

During this second stay, on Fergusson's recommendation, Davison decided to look for a property in Cap d'Antibes. The move was prompted by the fragile health of his young daughter, Doreen, who doctors feared would not survive another harsh winter. Within a few months Davison had bought a house called the Villa Gotte in Juan-les-Pins. Morris recalled:

> *When they were settled in, he [Davison] wrote saying we must come and spend Christmas with them. Our room opened onto the garden with palm trees and the beach beyond and the sound of the sea . . . Christmas dinner was on the terrace in blazing sun.*[35]

So began Fergusson's re-acquaintance with the South of France, an event of immense long-term significance for him creatively. The exotic winter holiday is recorded in his striking painting *Christmas Time in the South of France* (PL

52 *Goat*, 1921 CAT 161

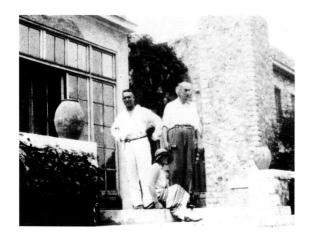

Fergusson and Walton at
the Château des Enfants,
Cap d'Antibes, c.1922

Fergusson at the Château
des Enfants, Cap
d'Antibes, c.1922

92 CAT 73) where pure, vibrant colour conveys the dazzling light and heat of
the Mediterranean. The strong, architectural design of the hilltown
dominating the composition evokes comparison with Mackintosh's late
watercolours executed soon after in Collioure and Port Vendres. Furthermore,
it was in the winter of 1921–22, that Fergusson led Davison to a derelict
château in pinewoods along a nearby stretch of coast. Davison decided to
purchase it and George Walton received a further commission to carry out the
necessary renovations. In 1923, Morris held the first of her Summer Schools
in the grounds of the newly christened Château des Enfants (so-called after
Davison's adopted family) which became their regular venue throughout the
1920s, '30s and '50s. In keeping with the liberating ethos of the schools and
the warm climate, Morris designed short tunics to maximise her dancers'
freedom of movement. She also colour-coded their outfits to distinguish
between different levels of learning.

Fergusson continued to play an active role in teaching painting, design
and sculpture at the schools. His creativity and preference for working
outdoors was reinvigorated by his annual immersion in these activities. The
positive atmosphere generated by the Summer Schools is captured by his
works based on Morris and her pupils which exude sensuality and health.

The portrait of Morris, *Megevian* (PL 82 CAT 96) – a subtle pun

combining her name with the French word for health – encapsulates this mood. A closely related preparatory study for this work (PL 81 CAT 203) demonstrates the revitalisation of his interest in the medium of watercolour. Typically, he used it to gather spontaneous impressions from which he would then paint more ambitious studio- based versions over a longer period of time. According to the composer Eugene Goossens, another friend of Davison's who was also involved with the early Summer Schools:

> *. . . the students adored 'Fergus' for his patience and efficiency and his faculty for linking up in his lectures the twin plasticities of paint and body movement. The rhythmic improvisations of the dance – in which Meg and her pupils excelled – he translated into terms of colour and brushstrokes so that . . . the two arts were synonymous in theory and practice.*[36]

The extensive château grounds, pinewoods and sea frontage, provided a perfect location for the school's outdoor-based activities, encouraging both sea and sun-bathing. The dancers' youthful, athletic presence did not go unnoticed, and it was not long before the owner of the local hotel, Monsieur Sella, invited Morris and her pupils to pose for photographs to promote a summer season in Cap d'Antibes. These joyful, high-spirited pictures taken at Eden Roc were reproduced in *Tatler* and *Vogue* helping to establish the Cap as a fashionable destination. It was soon to attract many of the best-known writers and painters of the day. Picasso notably met Fergusson there in 1924, apparently greeting him as an old friend and presenting him with a sprig of bog myrtle saying, 'You do not fit into this place. This is you'.[37] Fergusson pressed the wild plant and found that it had formed into the shape of his initials. He used this motif frequently thereafter as a cover design for his exhibition catalogues.

In 1922, travel in Scotland was to bear fruit, when Ressich proposed a tour of the Highlands. Beginning in Glasgow in May, their car journey lasted less than a fortnight but resulted in the production of numerous sketches and

Fergusson and Morris,
Cap d'Antibes, c.1935

Margaret Morris's
Summer School, c.1924,
Cap d'Antibes

Margaret Morris's
Summer School, c.1924,
Cap d'Antibes

watercolour studies such as *A Perthshire Landscape* (PL 93 CAT 187). On his return to London Fergusson quite literally locked himself away for six months, using this freshly gathered material to paint 15 canvases, which constitute his Highland Landscapes.

Six years later, Fergusson returned for a second Highland tour with Ressich, following which he executed related pictures such as *Cairngorm* (PL 95 CAT 90). Colour is more muted and restrained here, in keeping with the light and character of the Scottish climate and scenery. Densely packed brushstrokes layer colours one on top of the other in this painting recreating an impression of the rugged textures of the landscape. The snow-capped peaks in the background are perhaps more reminiscent of the Alps than the Cairngorms, but as elsewhere Fergusson used artistic licence when he felt this would provide a more harmonious result. The intensity and immediacy of his reaction to the Scottish landscape hints at the increasing importance which he attached to his artistic origins, feelings which led him ultimately to refer to Perthshire as his spiritual home and the source of his creativity.

It was the Highland Landscapes of 1922 which provided the basis for a string of subsequent exhibitions. Most immediately and importantly, they led to his first-ever solo shows in Scotland in 1923 at Aitken Dott's in Edinburgh and Alexander Reid's in Glasgow. The Leicester Galleries in London followed in 1924. Ressich had an instrumental role to play in the organisation of these exhibitions and, furthermore, in promoting not only Fergusson but also his contemporaries, Peploe, George Leslie Hunter (1877–1931) and Francis Campbell Boileau Cadell (1883–1937). Ressich's campaign for their acceptance and recognition in Scotland was mounted in a series of letters to the *Glasgow Herald*, and his efforts culminated with the four exhibiting for the first time as a group at the Galerie Barbazanges in Paris in 1924.

Encouraged by this contact, Fergusson became keen to re-establish a base in Paris and over the next four years he and Morris spent their time almost equally between addresses at the Hotel des Academies in Montparnasse and her London flat in Callow Street. In 1929, Fergusson found himself a studio

Exhibition catalogue featuring Picasso's bog myrtle sprig
FERGUSSON ARCHIVE

Exhibition catalogue, Galerie Barbazanges, Paris, 1924
FERGUSSON ARCHIVE

in the Parc Montsouris, to the south of Montparnasse. Exhibiting success during the intervening years focused in America, in 1926 at the Whitney Studio where his recent works received favourable reviews. The foreword to his exhibition catalogue was written by the American author, Charles MacArthur, with whom Fergusson had formed a friendship the previous summer at the Château des Enfants. It began:

> *Fortunately, John Duncan Fergusson is in Europe, which makes his introduction to America a rather simple matter. There is no telling how it would be accomplished with Fergusson around. He is one of those dour, wind-bitten Scots – at least three parts granite. As well shake hands with Ben Lomond.*
>
> *Such as Fergusson despises the gab and grimaces so necessary to further acquaintance. I'm sure that he is glowering at these restrained remarks of mine.*

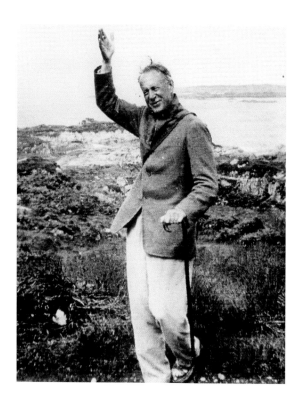

John S.M. Ressich

*For he is as blunt and straightforward as his work, and the only person who can
tell him anything is a man named Fergusson.*

*A famous London critic once said of him: 'I know of no living painter with
a more profound feeling for the music that is in colour. The joy of life and the joy
of stating it is everywhere in his work.' Yet Fergusson's work represents a very high
boiling point. He is not the one to faint at every sunset . . . There is great talk of
integrity nowadays. Here it is.*[38]

Another show in New York took place in 1928 at the Kraushaar Galleries.
This time Fergusson made the journey over with Ressich. Of the eighteen
paintings and six sculptures, the works that attracted the most press comment
were his nudes. The emphasis reflects not only the dominant focus of his
work over the preceding years, but perhaps the fact that he expected his nudes
to be more acceptable and saleable in this modern environment. Fergusson's
remarks on his first impressions of New York seem to support this view:

*Women and skyscrapers are the best interpretation of the spirit of the age. Men
are 'stuck in the mud' and 'standing still'. At least so says John Duncan
Fergusson, famous Scottish painter . . . Fergusson is in the United States on his
first visit, having arrived yesterday on the Transylvania with Capt. John Ressich,
a Scots novelist and journalist, elaborating on his first impressions of the city
Fergusson enthused, 'The air was just like Edinburgh and I saw one building on
the way down that struck me dumb, so beautiful it was. Just a plain office
building that didn't pretend to be anything else, but what a lift it gave me! That
is why I say the architecture of New York is the best expression of the modern age
that I've seen yet. These new skyscrapers are art – if they will only keep to the
present trend and won't start breaking the sweeping lines with a lot of silly
decorations. They are as simple, as sweeping as the modern woman, who is
efficiently artistic in everything she does.*[39]

Exhibition catalogue,
Kraushaar Galleries, New
York, 1928
FERGUSSON ARCHIVE

Exhibition catalogue,
Galeries Georges Petit,
Paris, 1931
FERGUSSON ARCHIVE

In March 1931 the internationally renowned Glasgow art dealer Alexander

Reid helped to organise a prestigious exhibition at the Galeries Georges Petit in Paris. It featured the work of Fergusson, Peploe, Hunter and Cadell, alongside Telfer Bear and R.O. Dunlop. Fergusson showed almost twice the number of exhibits as his colleagues. The foreword to the exhibition catalogue was written by the then British Prime Minister, Ramsay Macdonald. Fergusson's most ambitiously scaled exhibit – a sun-drenched nude reclining amid trees, *La Déesse de la Rivière* – was purchased by the French State on the opening day. Both Hunter and Peploe were similarly honoured and Peploe wrote to Fergusson from the South of France expressing his delight at what clearly represented a high point in terms of their collective artistic achievement: 'Heartiest of congratulations on your success . . . If I had been told in 1911, when we were in Paris, that I should have a picture in the Luxembourg, would I have believed it possible?'[40]

Fergusson had all the more reason to feel satisfied by his own purchase, as Reid had tried to dissuade him from exhibiting his nudes on the grounds that they were unlikely to sell. Fergusson's refusal to be put off demonstrates his characteristic integrity and reluctance to omit what had become by this stage the most representative of themes. Furthermore, in terms of his treatment, the integration of the female nude with the landscape as exemplified by his river goddess was highly typical. He emphasised unity between these elements visually through his rhythmic interweaving of both colour and brushstrokes across the surface of canvases such as *Nude with Oranges and Sunlight* (PL 79 CAT 86). By doing so, Fergusson hinted at the existence of a deeper and more spiritual bond between the nude and nature. This mystical connection was taken one step further by his images of Dryads (tree spirits). The earliest known example is, appropriately, a pinewood carving of a nude made in 1924 (PL 53), which conveys a sense of growth and power through its combination of elongated yet compact forms. In 1932 Fergusson reworked the theme in a delicate watercolour *Dryads, Cap d'Antibes* (PL 83 CAT 205), where three nudes merge in alternating rhythms with a series of slender tree trunks. A small watercolour study of nudes dancing among trees and rich foliage

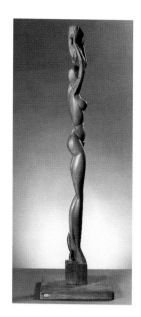

53 *Dryad*, 1924
oak
height: 845 mm
UNIVERSITY OF GLASGOW,
HUNTERIAN ART GALLERY

54 *Nudes Dancing Through Trees*, c.1930
CAT 393

underlines the ongoing and sustained closeness of such concerns with Margaret Morris's work (PL 54 CAT 393).

The 1930s was to be a decade of mixed fortunes. In December 1930, soon after Fergusson's return to Paris, George Davison died following the trauma of a forest fire in the grounds of the Château des Enfants. Fortunately, thanks to their friendship with his widow Joan, Fergusson and Morris continued to enjoy access to the château grounds and private bathing place. The decade also witnessed the deaths of all three of Fergusson's fellow Colourists – Hunter just months after the success of their Paris exhibition in 1931, Peploe

in 1935 and Cadell in 1937. By contrast, Fergusson would continue to work
and paint prolifically for a further three decades.

In 1932 he moved to a block of flats at 6 rue Ernest Cresson which was to
be the last of his Paris studios. Portraits and nudes continued to dominate his
output, many displaying a high degree of continuity with earlier interests,
such as *The Ochre Coat* (PL 73 CAT 102). The sitter was Roberta Paflin, who
like Anne Estelle Rice was a young American fashion artist recording the
latest Parisian collections for American magazines. She was to sit for a number
of paintings made in and around the Luxembourg Gardens over the years and
became a good friend of both Fergusson and Morris. During the 1930s
Fergusson and Morris also visited the American sculptor Jo Davidson in

Fergusson and Jo
Davidson at Becheron,
Loire Valley, c.1950

55 Study for *Voile
Indienne*, 1933
CAT 325

56 *Voile Indienne*, 1933
CAT 104

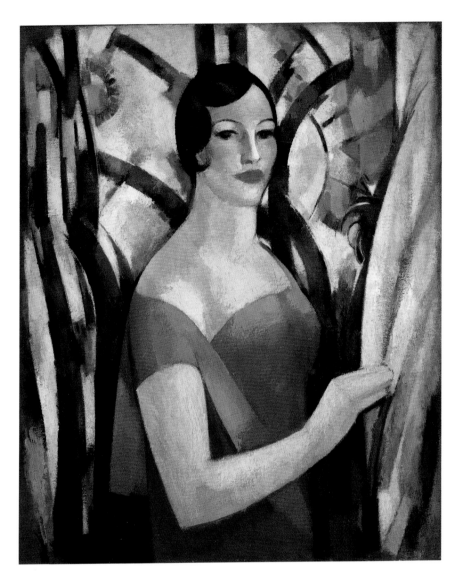

Sache, near Tours in the Loire Valley where he had purchased a country house, the Manoir de Becheron. The surrounding countryside inspired Fergusson to paint several restful, meditative landscapes in a fresher and more acidic palette such as *Thorenc: Tilleuls* (PL 96 CAT 99).

Otherwise, whilst in Paris Fergusson played an active role in establishing the Groupe d'Artistes Anglo-Américains, to which Davidson also belonged. The group held biannual exhibitions that were intended to show a representative cross-section of works by British and American artists living in Paris. In this way, they hoped to rekindle something of the group spirit and atmosphere from which they had benefited in the pre-war era. Fergusson became the president of the group in 1937 and in this year their fourth exhibition was held at the Schola Cantorum in the Rue St. Jacques. Fergusson's painting *Voile Indienne* (PL 56 CAT 104) was one of the two exhibits he included on this occasion. The venture does seem to have had considerable credibility with Pierre Bonnard cited on the Honorary Committee, while among its membership were artists such as Winifred Nicholson, Ethel Walker, Roderick O'Connor and the American Harold English.

It was whilst staying with Davidson in 1938 that Fergusson listened with growing concern to radio reports about the escalating international tensions which would ultimately lead to another world war. After spending the summer months in the South of France with Morris, he decided to give up his Paris studio and made arrangements to return to Scotland. According to Morris, 'War or no war, he said he felt the time had come when he should return to Scotland and try to help the young independent painters.' [41]

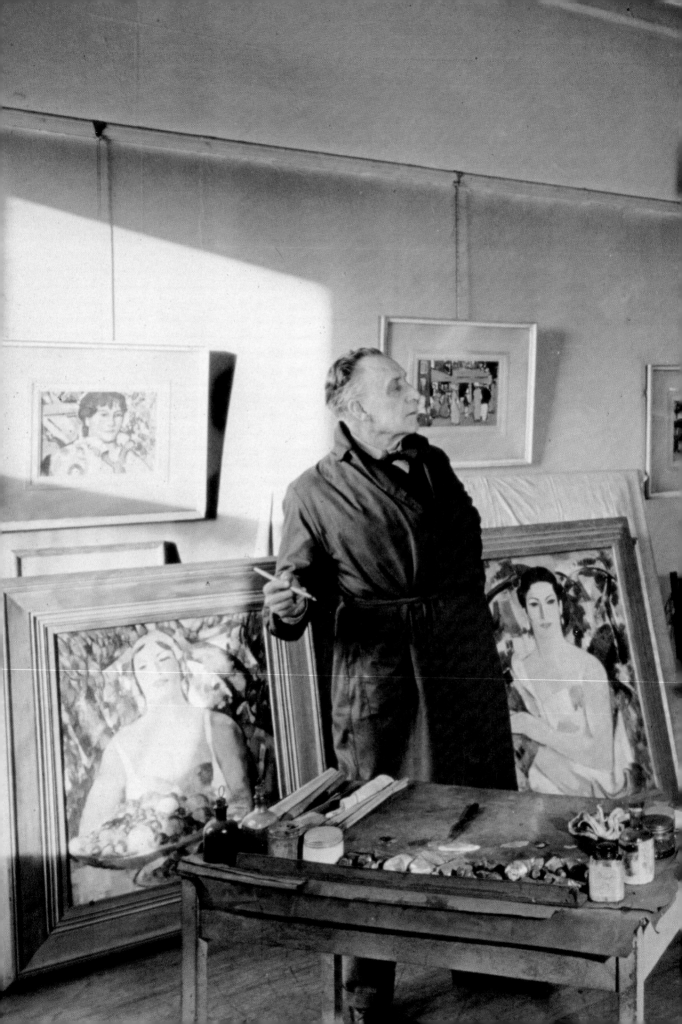

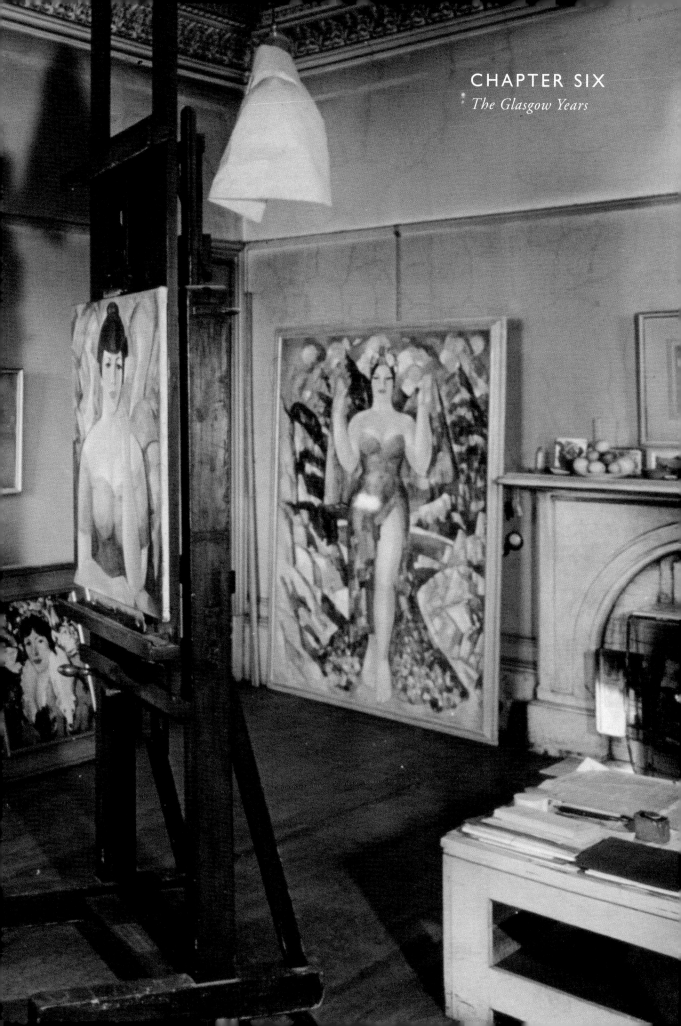

On their return to Scotland in 1939 Fergusson and Morris settled in Glasgow. From a practical perspective it was home to the most successful of the Margaret Morris Movement's schools, which had been set up there in 1936. For Fergusson, however, there was a deeper level of resonance. He felt that Glasgow was the most 'Highland' and therefore the most 'Celtic' city and as a result hoped to instigate a new wave of innovative Scottish painting there. These sentiments echo the conscious effort made during the last twenty years of Fergusson's life to emphasise his Scottish origins and to promote Scottish art in general. He remained critical of the art establishment in London and Edinburgh for perpetuating narrow, academic displays of work selected by committee and representing only well-known names; which also remained largely impervious to the significance of his contribution to the development of Scottish twentieth-century art.

The presence of both Fergusson and Morris in Glasgow inspired considerable respect from the wider artistic community. This was largely due to their direct links with early modernism. This status, combined with their personal charisma, attracted many keen to benefit from their experiences and creative lead. Consequently they soon made contact with other prominent figures in the Scottish cultural scene. In particular, Fergusson formed close friendships with the poet, Hugh MacDiarmid and the pioneering publisher William MacLellan, both of whom were key players in the Scottish Renaissance.

Although this was primarily a literary trend, Fergusson empathised wholeheartedly with their desire to revive Scottish artistic values. Of equal significance was MacDiarmid and MacLellan's related involvement with nationalist politics, which had gained considerable currency during the 1930s and '40s, following the founding of the Scottish Nationalist Party in 1934. Fergusson certainly advocated the idea that Scottish art had a distinct independent character. He also subscribed to many Nationalist periodicals on his return to Glasgow as well as acting as Art Editor to the radical journal, *Scottish Art and Letters*. [42]

Contrary to his apparent nationalist sympathies, he avoided adopting an

PREVIOUS PAGE

Fergusson in Clouston Street studio, Glasgow, c.1955

overtly political stance. In 1943, for instance, he chose not to sign a petition in support of the poet, academic and Scottish Nationalist, Douglas Young. Young had been imprisoned for resisting conscription by the British Government, on the grounds that he would only fight in the context of an independent Scottish army.[43] Fergusson's writings furthermore take care to stress his concerns from a cultural rather than a political perspective. More specifically, he qualified his nationalist sympathies by promoting a viewpoint that was international in outlook, arguing that Scotland and France had a shared Celtic heritage.

This was a key theme on which he elaborated in the single most important example of his writings, *Modern Scottish Painting*. It was commissioned by MacLellan in 1939 and published in 1943 as one of a planned series of books dealing with national cultural issues. It conveniently complemented Fergusson's personal agenda at this time, providing a vehicle through which to set out the views he had formed over his lifetime. In his foreword he explained that his chief aim was to help young Scottish artists and that he was writing it in 'the ordinary language of informal discussion'. [44]

The ideas in *Modern Scottish Painting* are idiosyncratic and do take a somewhat repetitive and rambling form, but they are delivered with a spontaneity and conversational zeal that makes it impossible to doubt the sincerity of Fergusson's underlying convictions. He introduces a number of topics through which he attempts to define the distinct character of Scottish art. In addition to his Francophile leanings, he celebrates a progressive Scottish artistic tradition that he identifies in the Glasgow School, Charles Rennie Mackintosh and Peploe. He also devotes a chapter to the theme of Scotland and Colour arguing with characteristic optimism for the central role in art and life of 'colour that makes for and associates itself with light, hopefulness, health and happiness'.[45]

Another recurrent idea is his continued criticism of official art and no less the puritanical, restricting effects of Calvinism. The creative driving force to which he returned throughout his life, however, was the notion of artistic

Cover for *Modern Scottish Painting*, 1943
FERGUSSON ARCHIVE

freedom. Explaining his decision to move to the bustling city of Paris he elaborated:

> *To go to Paris was the natural thing for the Scot . . . It doesn't seem to have*
> *occurred to the modern Scot that the Scottish Celt, when in France, was among*
> *his own people, the French Celts. French culture was founded by the Celts and*
> *invasions have not changed the fundamental character of the French people.*
> *Every Celt feels at home in France. The 'esprit Gaulois' [the Celtic spirit] still*
> *exists.*[46]

Fergusson's belief that Celtic tradition underpinned and fuelled his own creativity led him to make the following appeal.

> *If Scotland, or Celtic Scotland, would make a 'new alliance' with France, not*
> *political like the 'auld Alliance' but cultural, it would perhaps put Scotland back*
> *on to the main track of her culture, and let the Scots do something Scottish*
> *instead of imitation English, or rather second-rate British.*[47]

In this respect, Fergusson's stance reflected a broader cultural and literary trend on which the writer Maurice Lindsay has remarked, 'As well as the "Scottish Renaissance" side of his publishing activities . . . MacLellan also gave support to a somewhat self-conscious Celtic revival movement'. [48]

Self-conscious as some of their efforts may have appeared, Fergusson and Morris's shared Celtic concerns were put to practical use in encouraging those who were interested in creating original, innovative work. In 1940, Margaret Morris established her Celtic Ballet which set out to 'make a feature of ballet and drama based on Celtic legends, with music by modern Scottish composers and designs by modern Scottish artists'.[49] Following the success of this initiative, the New Art Club followed shortly after and came to share the Celtic Ballet's premises at 299 West George Street. The intention was to provide an alternative to official exhibiting options, as Fergusson explained:

Glasgow at the beginning of the war had no place where an independent artist without money could show his work. The only place to send to was the Glasgow Institute. The old Art Club – with an entrance fee, a yearly subscription of eight guineas, and a committee that refused to admit anyone they did not consider an important artist – was of course, out of the question for an artist without money, or a student, no matter how talented. A private show in a dealer's gallery cost one pound a day and printing expenses. This state of things was apparently accepted as quite in order or inevitable; some of us thought that it was not and decided to try to do something about it. So we arranged a meeting which was held in the School of Art, not as inappropriate a place as it would seem for the architect of the school, Charles Rennie Mackintosh, was one of the greatest and most independent artists Scotland has produced. We had quite a big meeting and, after a lot of discussion, it was agreed that there should be a New Art Club…We were very soon settled and had our first exhibition and discussion on the first of December, 1940.[50]

Regular meetings, held twice-weekly, soon attracted a broad membership of writers, poets, musicians and artists. The best known in addition to MacDiarmid and MacLellan, were the artist William Crosbie and the composer Erik Chisholm.

Glasgow benefited from a further significant injection of creative talent with the arrival of the Polish war emigrés, artists Jankel Adler and Josef Herman, both of whom were directly involved in Fergusson's artistic circle. Another well-respected figure who played a key part in the New Art Club from its inception was Andrew Taylor Elder. Like Fergusson, he had lived in Paris and was keen to share his knowledge of French art with others at the meetings. Speakers, either club members or invited guests, talked on a wide variety of subjects which were then opened up to informal discussion and debate. Unlike the exclusively male membership of the Glasgow Art Club, the New Art Club invited women to play an equal role. Students were also

encouraged to join by keeping fees to a minimum and allowing payment in instalments. Monthly art exhibitions were held on the club premises to give artists the chance to show their latest works.

Louise Annand (b. 1915), then a recent graduate of Glasgow University, was one of those on the first New Art Club Committee. In 1944 she painted an abstract composition titled, *New Art Club Meeting* that parodies the lively exchange of views taking place during the frequently heated debates. The individuals who are represented by specific symbols are identified by an accompanying key, which distinguishes elements such as 'circular discussions', 'row', 'Club bore bearing down', 'inconsequent remarks', taking place against a background described as, 'Scottish Nationalist with variations and shifting population of persons due to wartime'. 'Fergus' and 'Meg', as they were known by their friends, are represented by two constant, undulating lines of dark blue and pink respectively, running in parallel at the foot of the

New Art Club Meeting,
1944, Louise Annand
oil on paper on board
510 mm x 610 mm
PERTH & KINROSS COUNCIL

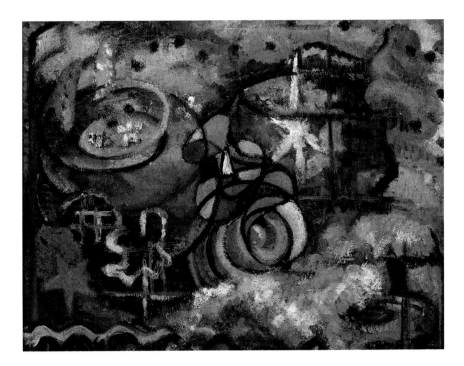

composition. In this way, Annand succinctly conveys the significance of Fergusson and Morris's joint bearing, not only in the course of the discussions, but as the bedrock of the club as a whole.

Contributing further to the cosmopolitan artistic vitality of wartime Glasgow, David Archer set up an even more informal and bohemian café, bookshop and discussion forum in 1941 called The Centre in Scott Street. Fergusson and Adler acted as Chair and Vice-Chair respectively and many members of the New Art Club joined. During its brief eighteen-month existence Adler, Herman, Crosbie and Taylor Elder all held solo exhibitions there.

A tendency for cross-fertilisation of ideas and influence was developed through the continuous interaction occurring between New Art Club and Celtic Ballet members. Many individuals were actively involved with both. The publisher MacLellan, for example, was one of the first recruits to sign up for the Celtic Ballet, while Taylor Elder designed the stage set and costumes for its first performance, *The Forsaken Mermaid* and Crosbie provided designs for *The Earth Shapers*. The interdisciplinary accent manifest in such collaborations was rooted in Fergusson and Morris's experiences of the Parisian avant garde in pre-1914 Paris.

In 1942, the New Scottish Group of painters was formed as an offshoot of the New Art Club, with Fergusson as President. The following year they began an even more ambitious series of public exhibitions, which were held at the McClure Gallery, Glasgow. Based on the French model of the Salon des Indépendants there was no selecting committee for these shows and the artists themselves were responsible for hanging their own works, in spaces allocated by ballot. The first of these exhibitions was opened by the playwright James Bridie (O. Henry Mavor). During the 1950s the group graduated on to the more spacious surroundings provided by the McLellan Galleries. At this point, however, the exhibiting also became more sporadic. Following shows in 1951 and 1953, the final display in 1956 was expanded to include works by the New Scottish Group and Other Independents. Signalling a gradual

Celtic Ballet programme, *The Forsaken Mermaid*, 1940
FERGUSSON ARCHIVE

Celtic Ballet programme, *The Earth Shapers*, 1941
FERGUSSON ARCHIVE

decline in interest, coupled with growing financial difficulties, the initiative appears to have lost impetus by the mid-1950s. In a broader art historical context, the significance of the New Scottish Group has been largely forgotten but its existence does convey something of the vibrancy of the artistic scene in 1940s Glasgow. Arguably of longer-term significance was Morris's Celtic Ballet of Scotland, which went on to form the basis of the Scottish National Ballet Company.

Collectively between 1943 and 1956 those artists involved in the New Scottish Group did produce a varied body of experimental works. One distinctive feature promoted by the topics of New Art Club discussions and manifest too in the majority of New Scottish Group works is a receptivity towards ideas from the Continent. Cézannesque or Cubist inspired design coupled with an expressionistic use of colour and brushwork to enhance mood are two of the most obvious results. Fergusson's intellectual leadership was clearly central to this. It paralleled his desire to revive the cultural links between France and Scotland voiced so strongly in *Modern Scottish Painting*. The lack of any recognisable group style meanwhile demonstrates the value that Fergusson placed on individuality and his overriding concern for artistic freedom. Annand, who exhibited in all nine of the New Scottish Group's shows, later reflected on his significance:

> *He had considerable influence on many young painters, including myself, in the 1940s partly by his very presence and example, but more because he showed interest in us, was tolerant and kind, and offered some practical advice. Kindness to young, inexperienced painters is not the usual quality in established artists and the fact that he accepted the premise that one was an artist, though as yet a little unskilled was the most heartening thing.*[51]

Although increasing amounts of Fergusson's time was devoted to supporting and encouraging others, he still found the time to paint himself. He and Morris rented a flat at 4 Clouston Street, which doubled as his studio for the

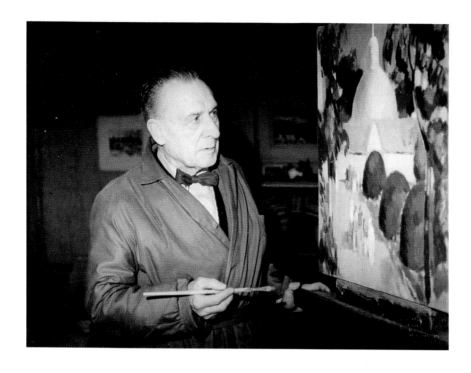

Fergusson in Clouston
Street studio, working on
*The Dome, Botanic
Gardens, Glasgow*, c. 1952

remainder of his career. It was suitably light and airy, being situated at the top corner of the tenement, with impressive views over the Botanic Gardens to the hills beyond. According to those who knew them, they led a somewhat spartan existence and were not at all materialistic. What Fergusson and Morris may have lacked in the way of creature comforts, however, was more than compensated for by their warmth and generosity of spirit. Morris seems to have played the more visible, outward role in the partnership. Her tireless flair, energy and enthusiasm formed a protective shield round Fergusson to some extent, enabling him to continue with his painting uninterrupted as much as possible. Both were dedicated and hard working, matched in Fergusson's case by a reluctance to part with works for less than he thought they were worth. This made selling a relatively rare occurrence. Sitters for his paintings continued to be found amongst Morris's pupils, who were also frequently involved with the activities of the New Art Club and the New

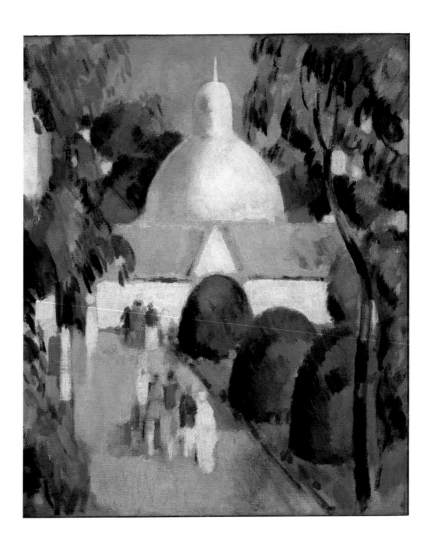

57 *The Dome, Botanic
Gardens, Glasgow,
1953* CAT 137

Scottish Group. The Botanic Gardens, directly across the river from his flat,
was to become a favourite sketching ground for Fergusson. The Gardens
provided the setting for *Mother and Child: Sheila* (PL 74 CAT 123), depicting
Sheila O'Shaunessy (née Neill). She was then a recent graduate of Glasgow
School of Art and became an active New Art Club and New Scottish Group
participant during the 1940s. A number of small watercolour sketches of the
same location also resulted in a small but important canvas of 1953, which

58 Study for *The Botanic Gardens, Glasgow*, c.1950
CAT 209

treats the subject afresh as a series of simple, sculptural volumes.

Bright colour continued to dominate Fergusson's palette, lending even his Scottish subjects a characteristically Mediterranean mood. After the war, however, the opportunity arose to spend further summers in the South of France, which in turn inspired ambitious canvases such as *Bathers: The Parasol* (PL 86 CAT 132) and *Blonde with Checked Sundress* (PL 75 CAT 138). An emphasis on increasingly vibrant colour, including a favourite intense pink, in combination with large areas of fragmented pattern, give a strongly decorative feel to the late figure paintings. In addition to their deliberate ornamental artifice, the contrived quality of many of his compositions was due mainly to the fact that Fergusson continued to paint from memory, combined with sketches made months, or even years, earlier.

Nudes and portraits continued to provide an endless source of fascination. By this stage the individual sitters were of little real consequence, as his images of women, both with and without clothes, had long settled into a formula. This involved the almost obsessive reworking of a stock figure, a personal and highly idealised vision which had changed little since the 1920s. His tireless repetition of full-figured, youthful nudes and his tendency to

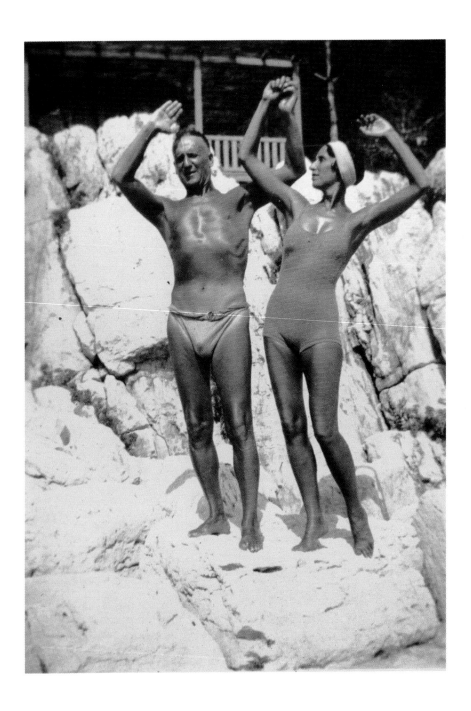

Fergusson and Morris,
Cap d'Antibes, c.1935

exaggerate sexual characteristics even in his portraits led many to view this aspect of his work with a certain unease. Raymond Drey observed, 'Some of his portraits suffered from this tendency to over-emphasise a voluptuous curve, a pigmentation of the lips and to change slender necks into columns of sculptural form. This heightened the femininity of the sitter at the expense of character and individuality'.[52] In the context of recent art historical debate re-examining the role of the female nude in painting, it would be easy to dismiss Fergusson's nudes as voyeuristic and reactionary.

It is important to acknowledge, however, that in keeping with his earliest paintings such as *At My Studio Window*, Fergusson perceived them as the embodiment of a set of modern and liberated values. Although his motivation for painting nudes was undeniably rooted in sexual attraction and focused on a procreative role, he was conscious that women were increasingly challenging conventional boundaries in respect of their intellectual and physical abilities. In this context, Fergusson's proud and unselfconscious nudes symbolised an enlightened perspective, acting as a visual equivalent for a new type of free, independent woman. Throughout his life he remained firmly focused on this view, rejoicing in fertility, naturalness and health as symbols of female power and vigour. There is, not surprisingly, a high degree of duality between Fergusson's art and life. His close relationships, for instance, testify to his admiration for strong, dynamic women and Morris's own work and example served to reinforce his ideals. The fact that this era also saw the development of naturism and the Women's League of Health and Beauty reveals the extent to which the personal philosophies of both Fergusson and Morris, reflected the wider social and sexual context of their times.[53]

Fergusson and Morris were free spirits and numerous holiday snapshots of them in the South of France capture something of the flavour of their lifestyle. They reveal not only their passion for sun-worship but also their impressive efforts to achieve and maintain the body-beautiful. Contrary to popular belief, they never married and, according to those close friends who knew them well, they chose not to have a family of their own, believing this

Fergusson, Cap d'
Antibes, c.1935

Fergusson and Morris,
Cap d'Antibes, c.1955

would be selfish in light of their foremost commitment to their respective careers.

Fergusson continued exhibiting, albeit somewhat erratically, after returning to Glasgow but didn't have another solo show in London until 1952. The greatest achievement of his later years was his first retrospective exhibition in 1948. It was held at the McLellan Galleries in Glasgow, before touring to Aberdeen, Ayr, Carlisle, Paisley and Belfast. The official opening was performed by Dr T.J. Honeyman, the influential Director of Kelvingrove Art Gallery and Museum. Honeyman became a great ally of Fergusson and was a regular attender at New Art Club meetings. Critical reaction to Fergusson's retrospective show was largely favourable.

> *Well sunlight from the South of France gleams on Glasgow walls. That is the climatic feat an artist can bring about. This particular artist, John Duncan Fergusson, makes an entire big salon of the McLellan Galleries blaze . . . He set off to that happy-go-lucky Bohemia of Paris in the first 1900s when you could live on a few francs a week and own an attic. With a penny cup of coffee, you could sit in the Café du Dome in Montparnasse all night and talk and Picasso and Matisse were on the rise and new ideas were wine . . . That was still the time when the sea beaches were peopled with long-legged Victorian bathing suits of Puritan ugliness and Isadora Duncan was protesting in open-air dancing that the Greek cult of the body was the way to health; and sunbathing was a revolution.*
>
> *From Fergusson's canvases you will get an impact of this revolution . . . They express the rebellion against the grey life, with an almost soapbox shout that the human body deserves the right of health and beauty . . . It is the pagan exultancy a normal northerner feels in the Southern sun . . .*
>
> *He has an instinct for rhythm which makes sense out of a picture just as it informs the shape and meaning of a dance. His pictures and his sculptures seem to move with musical rhythm.*[54]

Fine Green

59 Illustration for *In Memoriam James Joyce*, 1955 CAT 338

Cover for *In Memoriam James Joyce*, 1955
FERGUSSON ARCHIVE

Two years later, Fergusson received further distinction when an honorary degree was bestowed on him by the University of Glasgow and in this year he also showed at the Institut Français in Edinburgh. According to Morris this was one of the exhibitions he most enjoyed.

In 1952 Fergusson was working on an ambitious Celtic painting. Appropriately monumental in scale, it depicted Morris wearing one of the costumes that she had designed for her Ballet. Fergusson appropriately titled it *Danu, Mother of the Gods* (PL 76 CAT 134), after the Celtic goddess symbolising the positive virtues of light, growth and fruitfulness. Apparently, Fergusson had been waiting for some time to find a theme of suitable grandeur to match the scale of his canvas and he intended it to express his hope for the re-peopling of his native land. Honeyman referred to it as his 'masterpiece', elaborating:

In some respects this is an apotheosis of Fergusson's long career as an artist and as a Scot. In conception it derives from a visit to Iona. There are the rocks and the solemn grandeur of the mountains of Mull. The whole essence of the Highlands is extracted and transformed.[55]

The cloaked, mythological figure is portrayed in a suitably iconic pose, her monumental presence dwarfing the surroundings. In turn the landscape appears to owe little to its claimed source of inspiration, presenting as it does a theatrical backdrop of fantastical proportions, with sheer-sided valleys and towering, conical peaks. Danu, in keeping with Fergusson's nudes, encapsulates his celebratory vision, combining the themes of life-force and abundant Nature.

Another significant project that allowed Fergusson to develop his Celtic interests followed soon after. *In Memoriam James Joyce* was published in 1955 and Fergusson was invited to provide illustrations for the text. The book was a long poem by Hugh MacDiarmid, commissioned by William MacLellan as a tribute to the work of the Irish writer James Joyce. Within Fergusson's twenty-three curving, intertwining linear designs, he combines the Ogam alphabet, an ancient Celtic script of straight lines cutting across a vertical. According to notes he made around 1930, Ogam was the leader of the tribes of the goddess Danu, thus providing continuity with the earlier canvas. Furthermore, Fergusson had personal ties with Joyce, whom he had actually met whilst in Paris before 1914. This rhythmic series of illustrations was completed in 1954, his eightieth year, and is without doubt his most overt and complex Celtic statement. In a prefatory note about their inspiration he explains, 'The Decorations are composed of Joyce's initials in Ogam and other characters together with symbols that convey Joyce's concern with music, creation, feeling and his native Ireland'.[56]

In the late 1950s Fergusson embarked on one of the very last of his canvases, a huge work portraying two statuesque nudes set against a

Magnolia, the French
model who inspired *Two
Nudes* (PL 87 CAT 143)

background of magnolia flowers. Recalling the mystical symbolism that had informed his earlier 'dryad' images, Morris recalled that he intended the figures to evoke the spirit of the magnolia trees that he sketched every summer in the south. She also told how a young French girl whom he called Magnolia provided the inspiration for the painting.

1960 was to be the last summer which Fergusson and Morris spent together in Antibes. His failing health was increasingly evident by this stage and Fergusson died peacefully at home in Glasgow on 30 January 1961. In accordance with his wishes, his ashes were scattered at the top of Schiehallion in Perthshire, which he had long regarded as his ancestral home. Although she lived until 1980, Morris too chose this spot as her final resting place, spiritually reuniting them in what had been a truly unique partnership, both in life and art.

The latter half of Fergusson's painting career was dominated by his exuberant images of bathers and nudes, which for many hold an enduring appeal. Their vibrant colour and mood of exoticism and sensuality convey his immense love of life and capacity to appreciate its simplest pleasures. But although numerically strong, the artistic value of these works is less secure. Not only are they formulaic in treatment but they owe what was by this stage a long-outdated stylistic debt to Cézanne. Additionally and regardless of Fergusson's highly idealised vision, they also contain areas of unresolved anatomical weakness. Most obviously, hands and feet are notable by their absence and where they do feature are rarely handled convincingly. The real fascination of the late works is perhaps in their subtext – in the manner that they indirectly reflect the liberated philosophy and inspiring lifestyle that he shared with Morris. By contrast, the earlier half of Fergusson's artistic output was varied, experimental and constantly evolving in response to change.

From the earliest Edinburgh days he had shown his ability for independent thinking coupled with a rebellious streak. This was evident not least in his decision to become self-taught. In time, his tendency to question authority led

him to distance himself from official art of all kinds and to value the fundamental principle of freedom most highly of all. Integrity and singularity of purpose in pursuit of his artistic ideals was a constant feature. He repeatedly refused to compromise his artistic vision, whether by accepting commissioned portraiture, the advice of dealers or responding to external demands such as those imposed by the Ministry of Information for his war paintings.

His conscious desire to ally himself with progressive tendencies not only in Scotland but beyond led him actively to seek out new challenges and contributed to his love of travel. It was to be in the relaxed and bohemian, yet vibrant and stimulating atmosphere of Parisian Café society that he found the freedom of attitude that he sought. There he was able to share and exchange ideas with other like-minded individuals.

Throughout his life his gregarious nature and considerable personal charisma repeatedly brought him into contact with a fascinating range of artists and intellectuals. In turn he embraced a broad array of influences which incorporated contemporary philosophy during his Paris years and Celticism in later life. His desire to fuse intellectual concerns with his painterly preoccupations indicates a level of ambition that exceeded that of his fellow Colourists. Fergusson was also more adventurous in terms of the range of themes that he tackled, which, in addition to landscape, still life and portraits, included not only the nude but his war paintings and sculpture.

The sheer variety of his work demonstrates his versatility and willingness to experiment. It was his open outlook, coupled with his strong personal vision, which enabled him to respond successfully to the radical innovations he encountered following his move to Paris. Fergusson's direct, sustained contact with cutting-edge activities at this critical point in the history of art was unusual amongst his British contemporaries.

It was whilst living there between 1907 and 1913, fully immersed in and engaging with the developments which gave rise to early Modernism, that he produced his best work. Above all, it is on these foundations that Fergusson's reputation stands.

PLATES

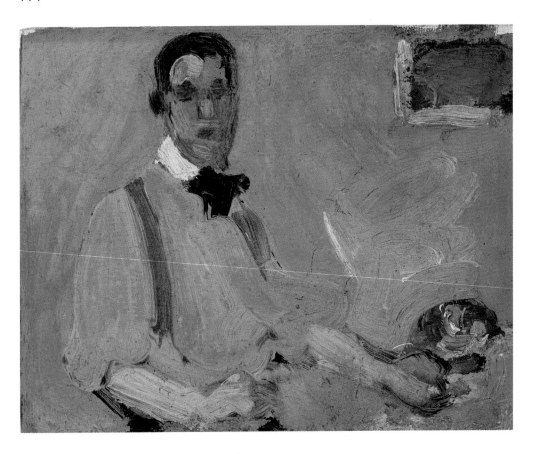

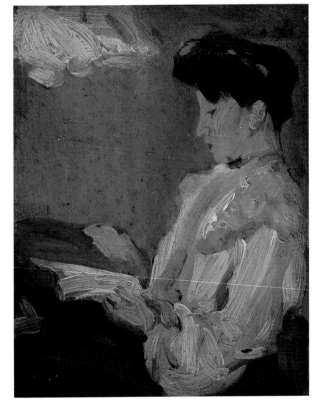

60 *Red Braces: Self Portrait*
 c.1900 CAT 15

61 *Lamplight,* c.1900 CAT 11

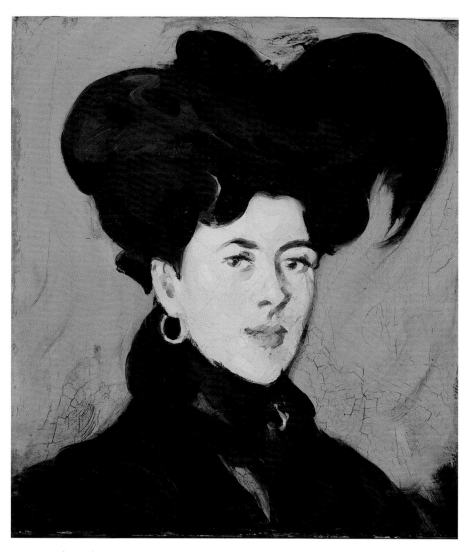

62 *Jean: The Cock Feather,* 1903 CAT 30

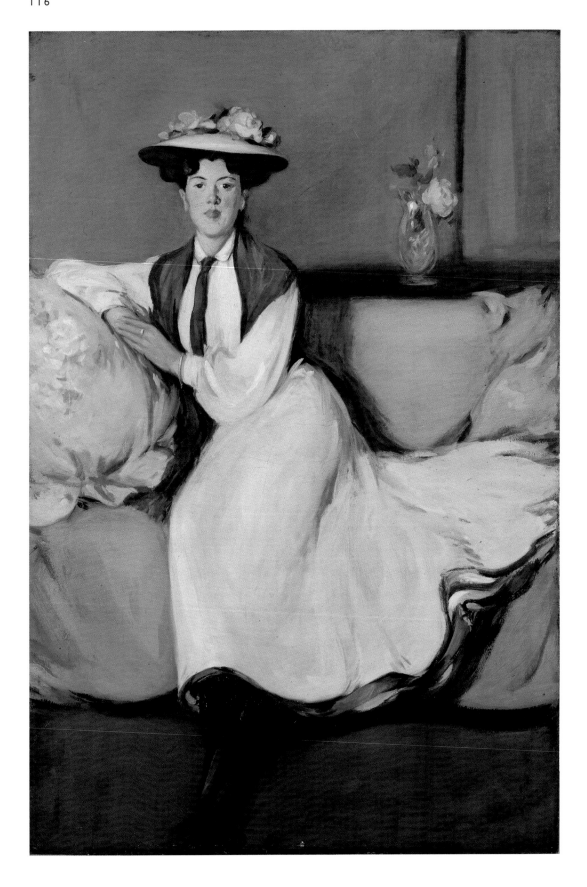

63 *The White Dress:*
Portrait of Jean, 1904
CAT 37

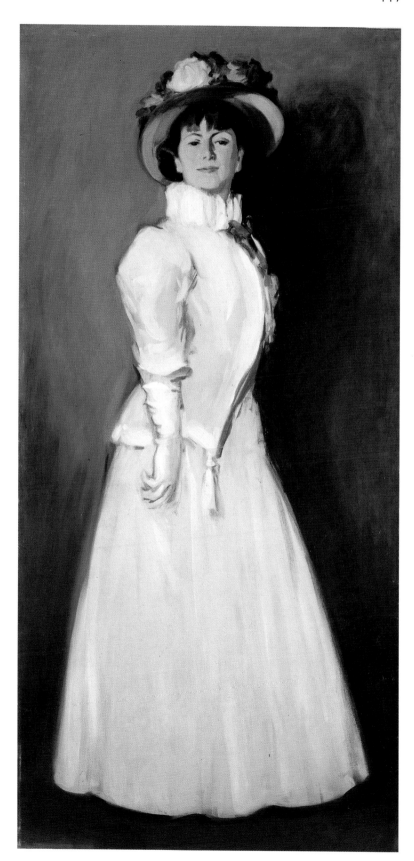

64 *The White Ruff*, 1907
CAT 43

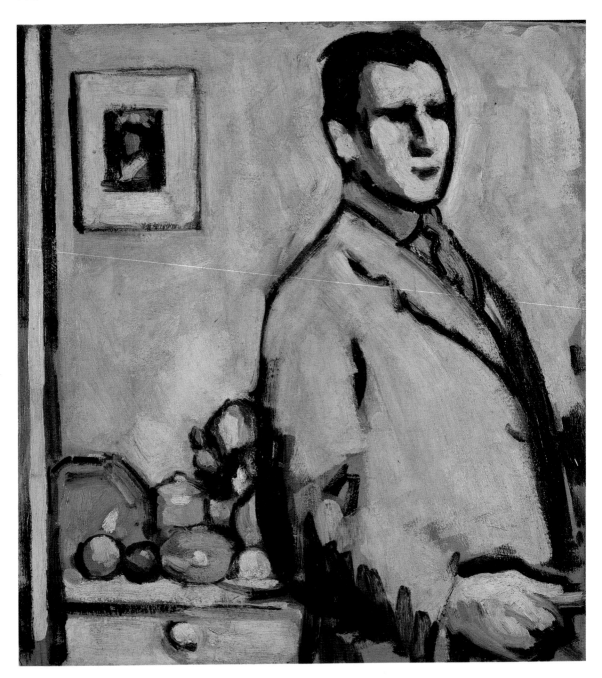

65 *Self Portrait*, 1907 CAT 41

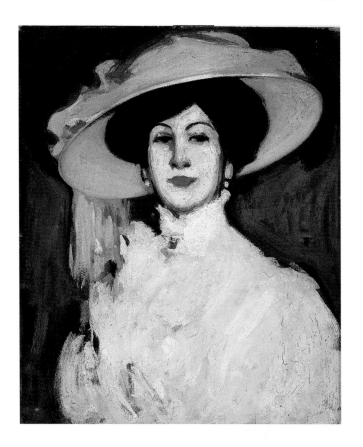

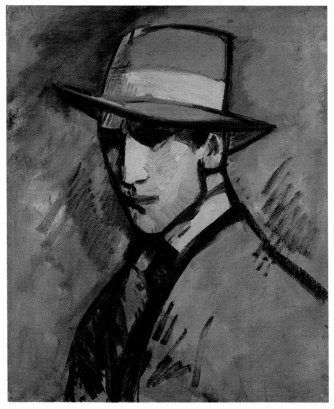

66 *The Hat with the Pink Scarf*, 1907 CAT 42

67 *Self Portrait: The Grey Hat*, 1909 CAT 52

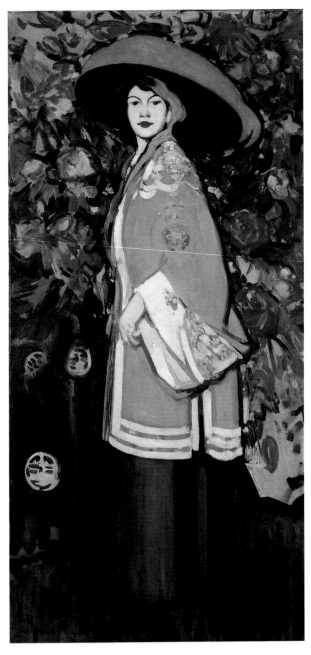

68 *Le Manteau Chinois*, 1909
CAT 51

69 *Lady with Dog*, c.1910
CAT 177

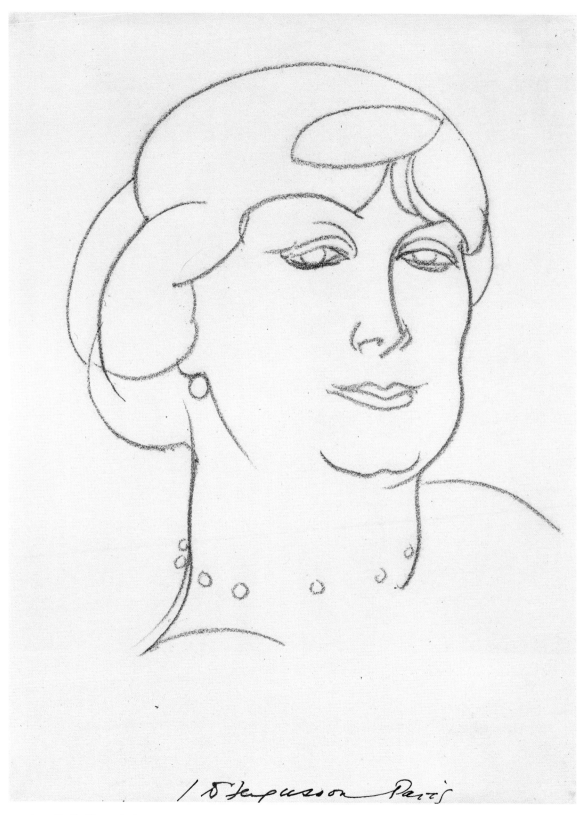

70 *Anne Estelle Rice*, c.1910 CAT 222

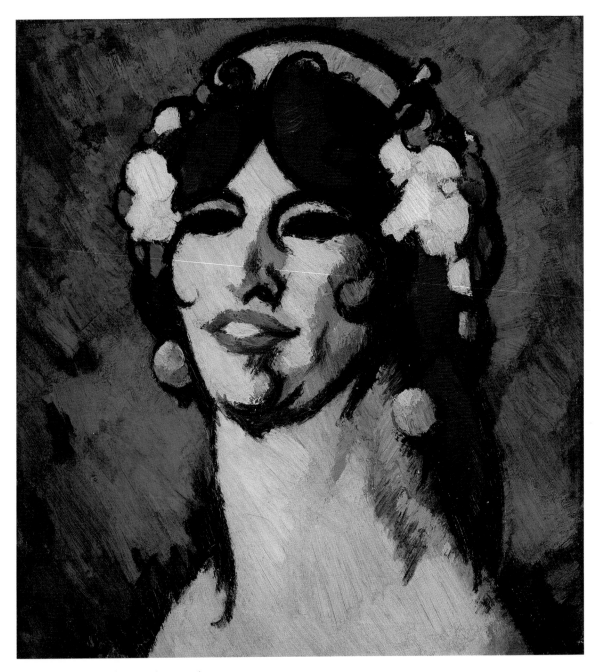

71 *Margaret Morris dans Le Chant Hindu,* 1918 CAT 70

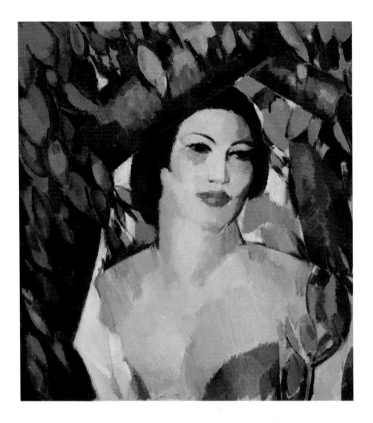

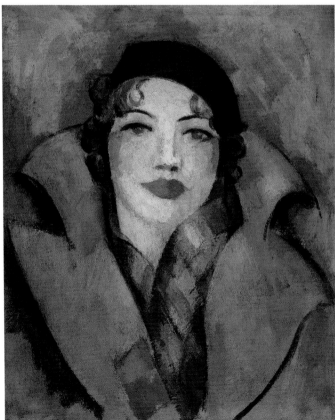

72 *The Branches,* 1928
CAT 88

73 *The Ochre Coat,* 1933
CAT 102

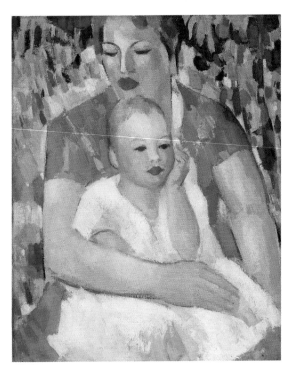

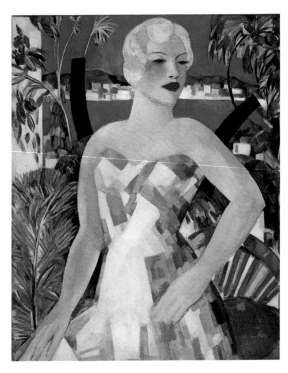

74 *Mother and Child:*
 Sheila, 1944 CAT 123

75 *Blonde with Checked*
 Sundress, 1958 CAT 138

76 *Danu, Mother of the*
 Gods, 1952–3 CAT 134

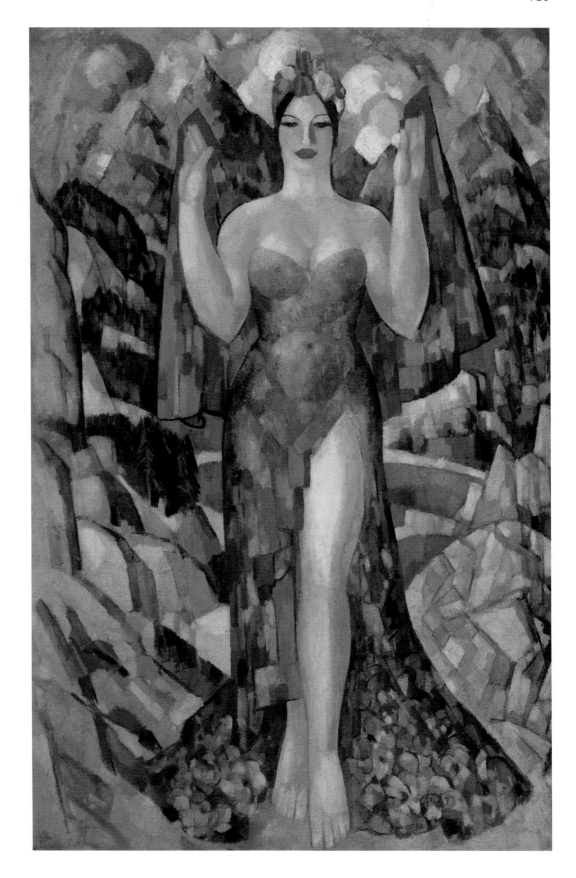

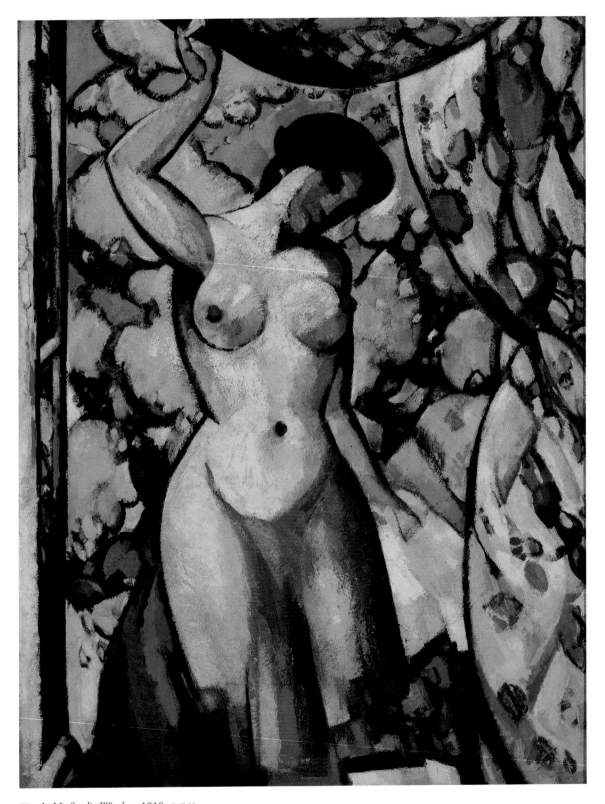

77 *At My Studio Window*, 1910 CAT 55

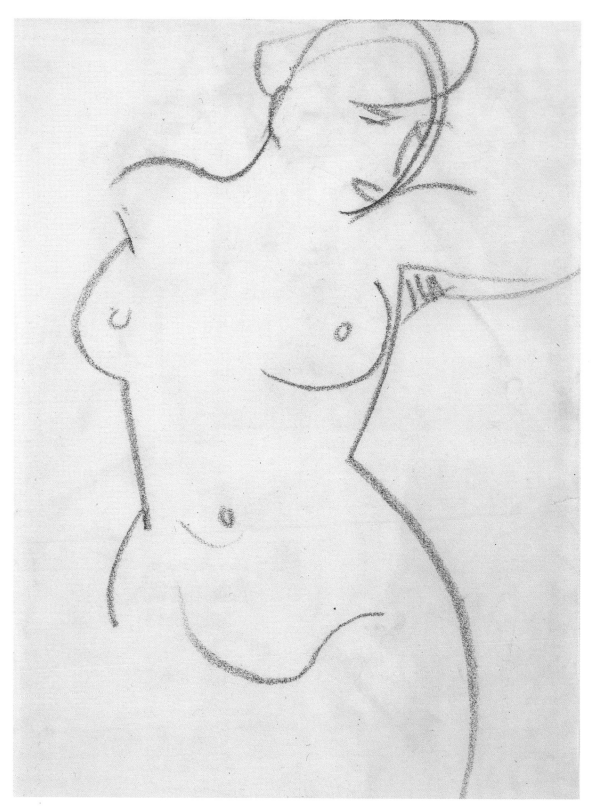

78 *Study of a Nude*, 1911 CAT 272

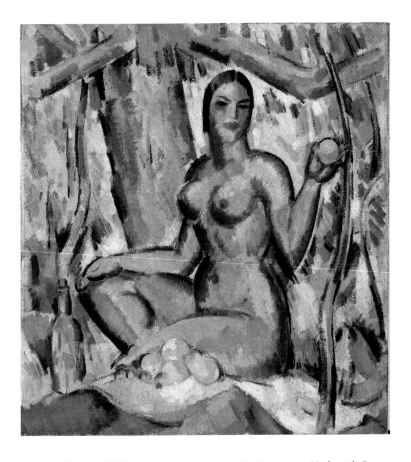

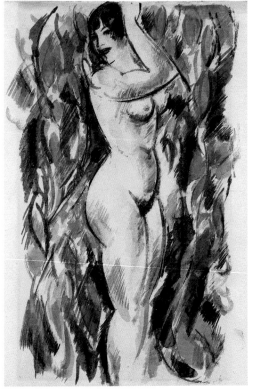

79 *Nude with Oranges and Sunlight,*
1928 CAT 86

80 *Nude and Foliage,* c.1931
CAT 204

81 Study for *Megevian*, 1931
CAT 203

82 *Megevian*, 1931 CAT 96

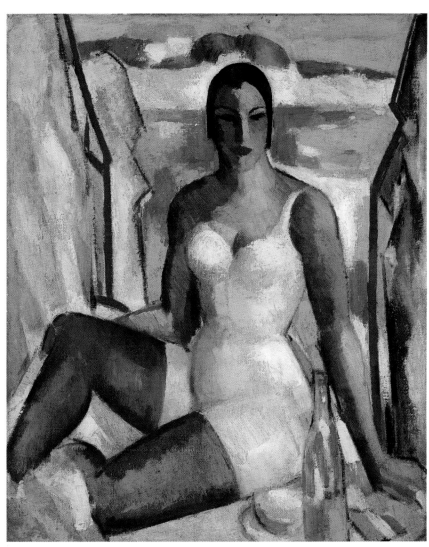

83 *Dryads, Cap d'Antibes*, 1932 CAT 205

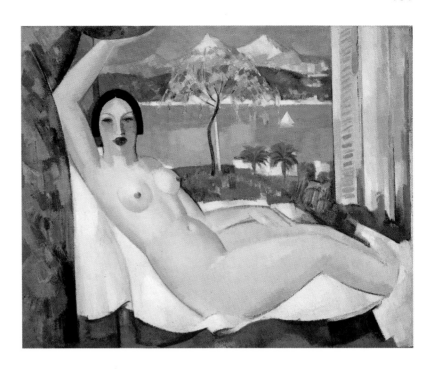

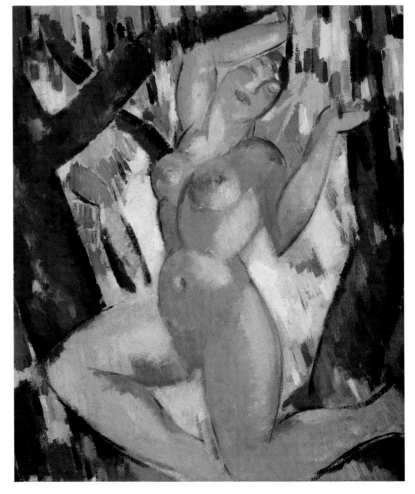

84 *Spring in the South,*
1934 CAT 106

85 *Golden Nude,* 1937
CAT 111

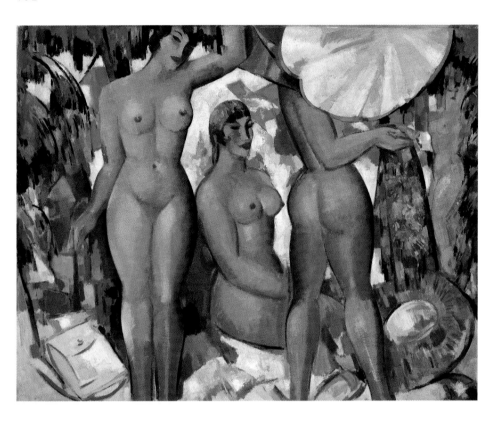

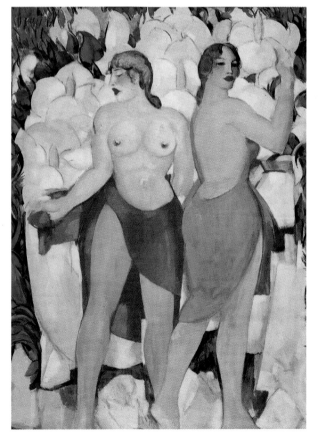

86 *Bathers: The Parasol,*
1951 CAT 132

87 *Two Nudes,* 1959
CAT 143

88 *Girl in Field*, c.1900
CAT 10

89 *Satyr*, c.1900 CAT 17

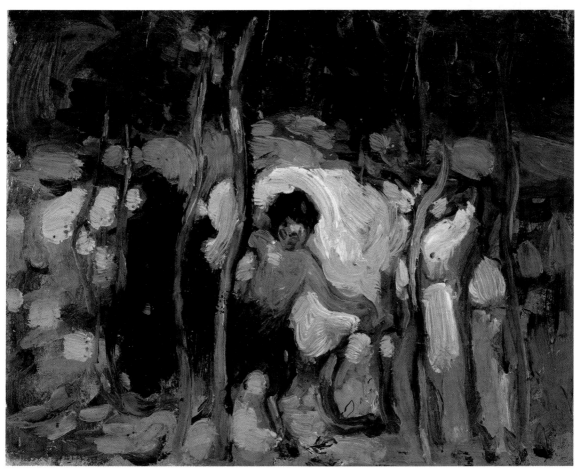

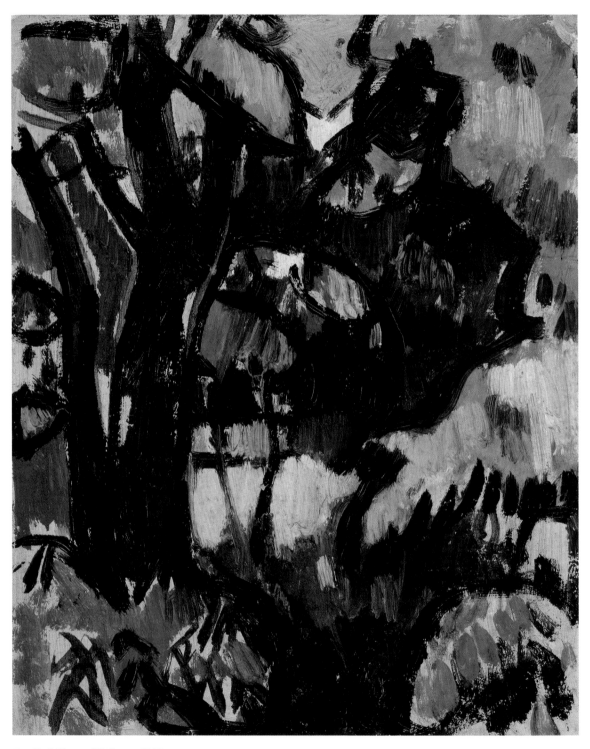

90 *Dark Tree and Foilage*, c.1908 CAT 46

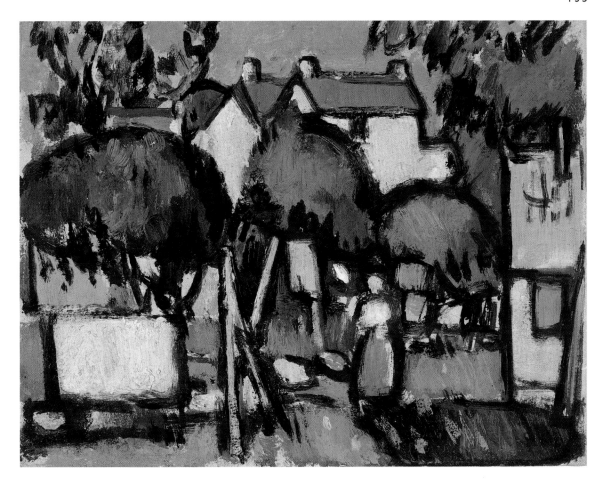

91 *Roofs at Saintonge,* 1910 CAT 60

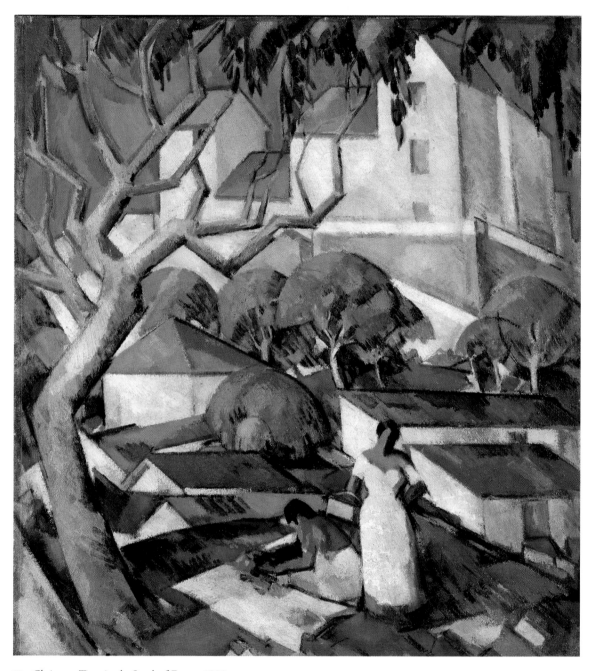

92 *Christmas Time in the South of France*, 1922 CAT 73

PURCHASED WITH THE ASSISTANCE OF THE HERITAGE LOTTERY FUND

93 *A Perthshire Landscape,*
1922 CAT 187

94 *Clouds in Wales*, 1926
CAT 192

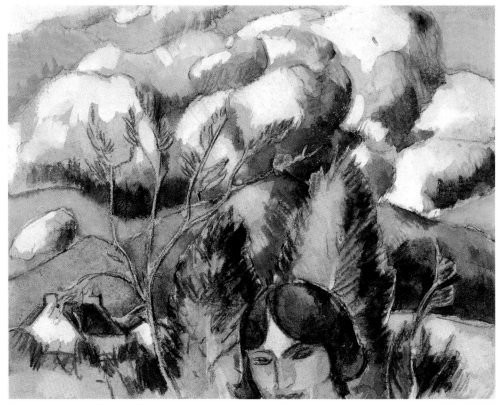

95 *Cairngorm*, 1929 CAT 90

96 *Thorenc: Tilleuls*, 1931 CAT 99

97 *The Trocadéro, Paris,* c.1902 CAT 168

PURCHASED WITH THE ASSISTANCE OF THE NATIONAL FUND FOR ACQUISITIONS

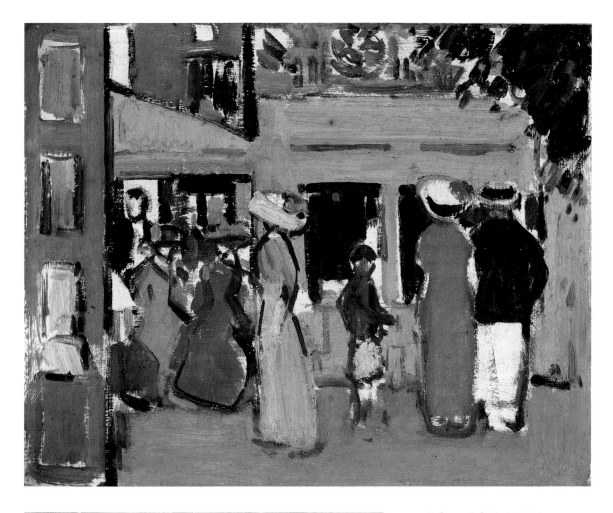

98 *Before a Café: Paris*, 1907 CAT 38

99 *Café Scene*, 1907 CAT 170

100 *Boulevard Edgar Quinet, Paris,* 1907 CAT 39

101 *Paris Street Scene*, 1908 CAT 47

102 *Carrefour de l'Observatoire*, 1908
CAT 44

103 *Closerie des Lilas*, 1908
CAT 45

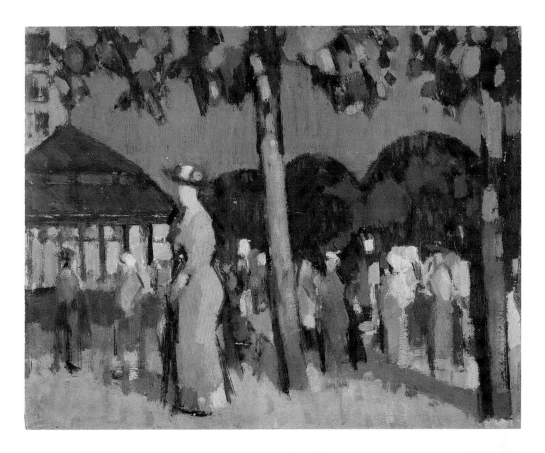

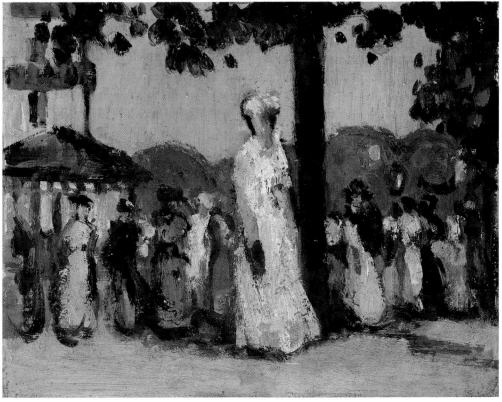

104 *Woman on a Balcony*, c.1909 CAT 53

105 *A Back Street in Royan*, 1910 CAT 54

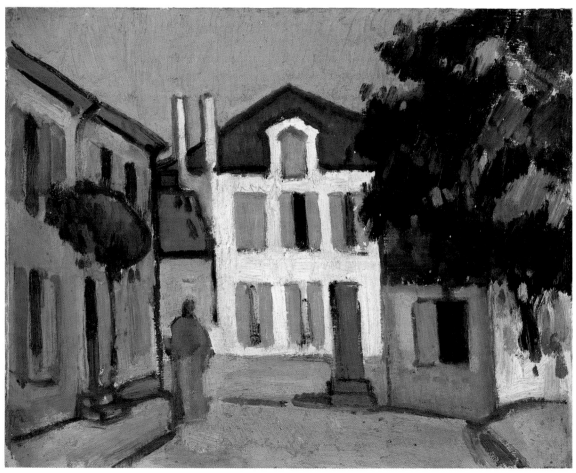

106 *Arab Fishermen and Boats*, c.1899 CAT 3

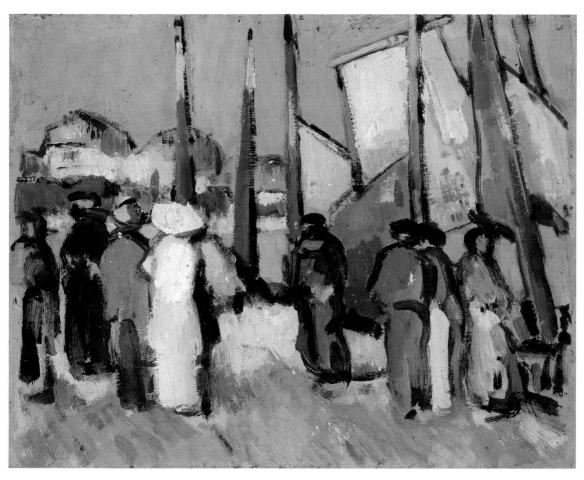

107 *People and Sails at Royan*, 1910 CAT 58

108 *Loading in Royan
Harbour*, 1910 CAT 57

109 *Bathing Boxes and
Tents at St Palais*,
1910 CAT 56

110 *Spray*, 1914 CAT 183

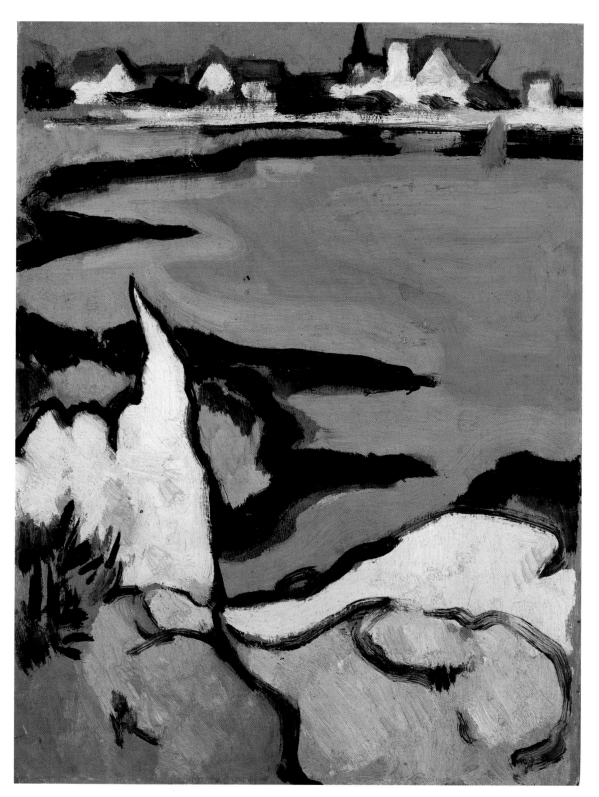

111 *Rocks and a Bay,* 1912 CAT 64

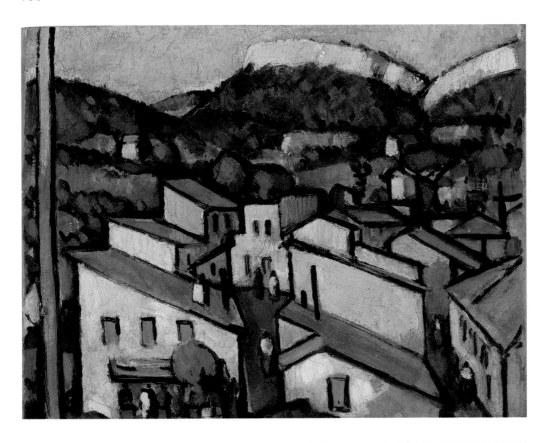

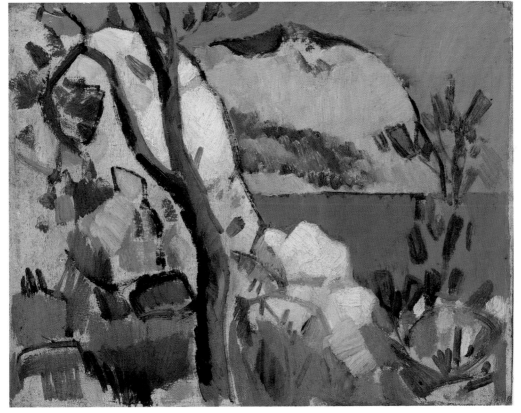

112 *Cassis from the West*, 1913
CAT 66

113 *Cassis*, 1913 CAT 65

114 *Three Submarines*, 1918
CAT 71

115 *Blue Submarine: Portsmouth
Harbour*, 1918 CAT 69

116 *Château,* c.1925 CAT 77

117 *Packet of Matches and
Match Box,* c.1898
CAT 2

118 *Still Life: Teapot,
Flowers and Fruit,*
c.1912 CAT 63

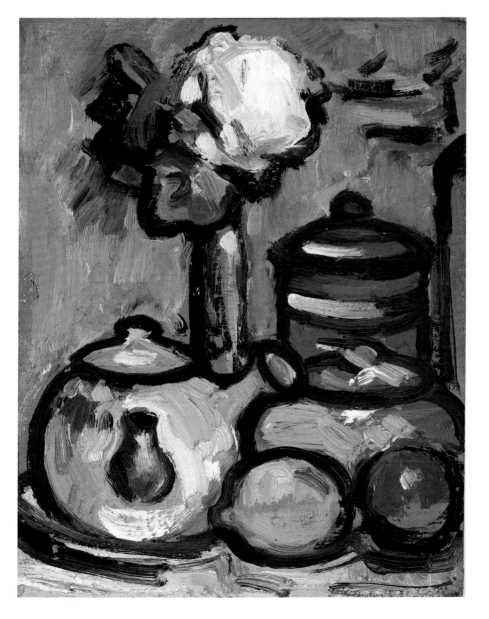

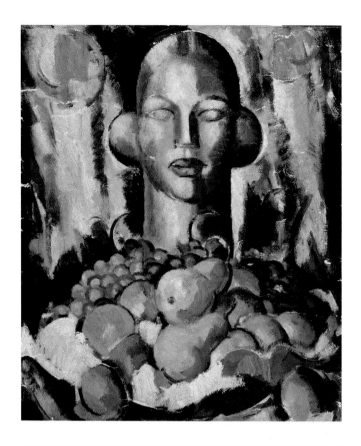

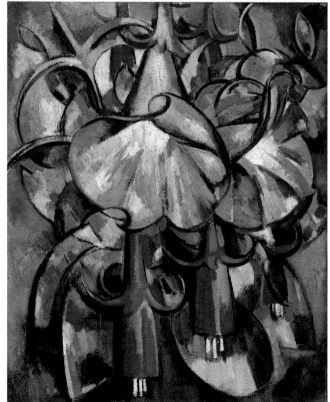

119 *Eastre and Fruits,*
1929 CAT 91

120 *Gloxinias and Fuchsias,*
1938 CAT 113

121 *Chimney Pots*, 1959 CAT 139

CATALOGUE

The following entries list all of J. D. Fergusson's oil paintings and sculpture from the Fergusson Gallery's permanent collection. In addition, a selection of his watercolours, drawings, and a summary of the contents of his sketchbooks are included. A substantial archive containing several thousand items, including letters, press cuttings, photographs, catalogues, periodicals and other related ephemera, accompany the artworks. This material and the reserve collection can be consulted by appointment at the Fergusson Gallery. Perth and Kinross Council hold copyright for the works of J. D. Fergusson.

Section I
OIL PAINTINGS

1 *The Artist's Brother*
 1898
 oil on canvas
 635 mm × 535 mm
 1992.124

2 *Packet of Matches and
 Match Box*
 1898 (circa)
 oil on panel
 250 mm × 180 mm
 1992.125

3 *Arab Fishermen and Boats*
 1899 (circa)
 oil on canvas on board
 268 mm × 340 mm
 1992.123

4 *Artist's Sister at Piano*
 1900 (circa)
 oil on board
 140 mm × 115 mm
 1992.317

5 *Cliff Top Cottage*
 1900 (circa)
 oil on panel
 115 mm × 140 mm
 1992.318

6 *Cottage with Figures*
 1900 (circa)
 oil on panel
 140 mm × 110 mm
 1992.122

7 *Craigleith Quarry*
 1900 (circa)
 oil on panel
 115 mm × 140 mm
 1992.327

8 *Farm in Landscape*
 1900 (circa)
 oil on card
 115 mm × 140 mm
 1992.321

9 *Figures on Cliff Top*
 1900 (circa)
 oil on panel
 140 mm × 115 mm
 1992.336

10 *Girl in Field*
 1900 (circa)
 oil on card
 140 mm × 115 mm

11 *Lamplight*
 1900 (circa)
 oil on panel
 115 mm × 140 mm
 1992.128

12 *Landscape with Figure*
 1900 (circa)
 oil on card
 140 mm × 115 mm
 1992.313

13 *Point de Granville,
 Normandie*
 1900 (circa)
 oil on panel
 115 mm × 75 mm
 1992.338

14 *Princes Street Gardens,
 Edinburgh*
 1900 (circa)
 oil on panel
 135 mm × 115 mm
 1992.121

15 *Red Braces: Self Portrait*
 1900 (circa)
 oil on board
 115 mm × 140 mm
 1992.340

16 *Ross Fountain: Princes
 Street Gardens*
 1900 (circa)
 oil on wooden panel
 115 mm × 140 mm
 1992.326

17 *Satyr*
 1900 (circa)
 oil on cardboard
 115 mm × 140 mm
 1992.316

18 *Seascape: Lady with
 Parasol*
 1900 (circa)
 oil on panel
 115 mm × 140 mm
 1992.328

19 *Stream with Trees*
 1900 (circa)

1992.320

20 *Trees*
 1900 (circa)
 oil on panel
 115 mm × 145 mm
 1992.315

21 *Trees and Cliff*
 1900 (circa)
 oil on panel
 145 mm × 110 mm
 1992.319

22 *White Dress in the Garden*
 1900 (circa)
 oil on panel
 115 mm × 140 mm
 1992.312

23 *Fiacre in Spanish Street*
 1901 (circa)
 oil on panel
 140 mm × 115 mm
 1992.323b (verso)

24 *Spaniard*
 1901 (circa)
 oil on panel
 140 mm × 115 mm
 1992.323a (recto)

25 *Spanish Senorita in
 Mantilla*
 1901 (circa)
 oil on board
 305 mm × 255 mm
 1992.126

26 *Landscape at Peebles*
 1902
 oil on panel
 190 mm × 240 mm
 1992.127

27 *The Artist's Sister*
 1902
 oil on panel
 140 mm × 115 mm
 1992.322

28 *French Village with
 Figures*
 1903 (circa)

oil on panel
140 mm × 115 mm
1992.335

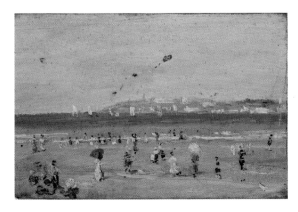

122 *Point de Granville, Normandie*, c.1900 CAT 13

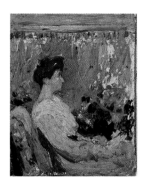

123 *The Artist's Sister*, 1902

CAT 27

oil on panel
190 mm × 240 mm
1992.129

29 *Japanese Still Life with
Fan*
1903
oil on canvas
410 mm × 355 mm
1992.130

30 *Jean: The Cock Feather*
1903
oil on canvas
510 mm × 460 mm
1992.341

31 *The Japanese Statuette*
1903
oil on canvas
550 mm × 385 mm
1992.132

32 *Tom*
1903
oil on canvas
665 mm × 560 mm
1992.131

33 *Figures on the Seashore*
1904 (circa)
oil on board
140 mm × 115 mm
1992.204

34 *John Baillie*
1904
oil on canvas
535 mm × 560 mm
1992.232

35 *Vase and Flower on Book*
1904
oil on board
265 mm × 340 mm
1992.234

36 *Seascape*
1904-1905 (circa)
oil on wooden panel
185 mm × 240 mm
1992.203

37 *The White Dress: Portrait
of Jean*
1904
oil on canvas
1780 mm × 1205 mm
1992.135

38 *Before a Café: Paris*
1907
oil on board
350 mm × 265 mm
1992.205

39 *Boulevard Edgar Quinet,
Paris*
1907
oil on board
350 mm × 265 mm
1992.206

40 *Paris Plage*
1907
oil on board
190 mm × 240 mm
1992.208

41 *Self Portrait*
1907
oil on canvas
540 mm × 510 mm
1992.207

42 *The Hat with the Pink
Scarf*
1907
oil on board
762 mm × 629 mm
1992.209

43 *The White Ruff*
1907
oil on canvas
2000 mm × 975 mm
1992.210

44 *Carrefour de
l'Observatoire*
1908
oil on panel
275 mm × 315 mm

1992.221

45 *Closerie des Lilas*
1908
oil on board
1992.211

46 *Dark Tree and Foliage*
1908 (circa)
oil on panel
235 mm × 195 mm
1992.213

47 *Paris Street Scene*
1908
oil on wooden panel
350 mm × 270 mm
1992.212

48 *Street Scene*
1908 (circa)
oil on panel
140 mm × 115 mm
1992.311

49 *Bouquet*
1909
oil on board
510 mm × 410 mm
1992.217

50 *Dark Sea and Red Sail*
1909
oil on board
350 mm × 265 mm
1992.214

51 *Le Manteau Chinois*
1909
oil on canvas
1995 mm × 970 mm
1992.216

52 *Self Portrait: The Grey
Hat*
1909
oil on board
610 mm × 510 mm
1992.215

53 *Woman on a Balcony*
1909 (circa)
oil on board
240 mm × 190 mm
1992.218

54 *A Back Street in Royan*
1910
oil on board
345 mm × 270 mm
1992.219

55 *At My Studio Window*

1910
oil on canvas
1575 mm × 1230 mm
1992.222

56 *Bathing Boxes and Tents at
St. Palais*
1910
oil on board
256 mm × 355 mm
1992.134

57 *Loading in Royan
Harbour*
1910
oil on panel
265 mm × 350 mm
1992.133

58 *People and Sails at Royan*
1910
oil on board
275 mm × 345 mm
1992.220

59 *Étude de Rhythm*
1910
oil on board
250 mm × 610 mm
1992.275

60 *Roofs at Saintonge*
1910
oil on board
265 mm × 350 mm
1992.233

61 *Royan*
1910
oil on wooden panel
350 mm × 270 mm
1992.223

62 *Vase of Flowers*
1911
oil on card
104 mm × 88 mm
1992.183

63 *Still Life: Teapot with
Flowers and Fruit*
1912 (circa)
oil on panel
240 mm × 195 mm
1992.308

64 *Rocks and a Bay*
1912
oil on wooden panel
340 mm × 265 mm
1992.235

65 *Cassis*
1913
oil on board
280 mm x 345 mm
1992.237

66 *Cassis from the West*
1913
oil on board
265 mm x 345 mm
1992.236

67 *A Harbour in the South*
1914 (circa)
oil on board
185 mm x 235 mm
1992.342

68 *Gypsy*
1916
oil on board
340 mm x 400 mm
1992.240

69 *Blue Submarine: Portsmouth Harbour*
1918
oil on canvas
560 mm x 610 mm
1992.241

70 *Margaret Morris dans Le Chant Hindu*
1918
oil on canvas

440 mm x 400 mm
1992.242

71 *Three Submarines*
1918
oil on board
280 mm x 350 mm
1992.239

72 *The Grand Hotel, Pourville*
1915
oil on panel
115 mm x 150 mm
1992.238

73 *Christmas Time in the South of France*
1922
oil on canvas
610 mm x 558 mm
1998.495

74 *Bathers: The Breeze*
1923
oil on canvas
715 mm x 610 mm
1992.250

75 *At Gows*
1925
oil on canvas
565 mm x 365 mm
1992.251

76 *At the Pond*
1925
oil on canvas
715 mm x 610 mm
1992.304

77 *Château*
1925 (circa)
oil on panel
115 mm x 145 mm
1992.331

78 *Farm Steading*
1925 (circa)
oil on panel
115 mm x 140 mm
1992.329

79 *House in Rocky Landscape*
1925 (circa)
oil on panel
115 mm x 150 mm
1992.332

80 *Houses in Trees*
1925 (circa)
oil on panel
115 mm x 150 mm
1992.325

81 *Houses with Seaview*
1925 (circa)
oil on panel
115 mm x 140 mm
1992.334

82 *House with Tower*
1925 (circa)
oil on panel
115 mm x 140 mm
1992.333

83 *Rock Pool*
1925 (circa)
oil on panel
115 mm x 145 mm
1992.330

84 *The Pond*
1925 (circa)
oil on panel
1992.314

85 *The Mountain Path, Thorenc*
1927
oil on canvas
755 mm x 910 mm
1992.252

86 *Nude with Oranges and Sunlight*

1928
oil on canvas
610 mm x 560 mm
1992.253

87 *Seated Nude Among Trees*
1928
oil on canvas
610 mm x 560 mm
1992.254

88 *The Branches*
1928
oil on canvas
585 mm x 550 mm
1992.307

89 *Woman with Fruit at the Dinner Table*
1928
oil on canvas
585 mm x 640 mm
1992.306

90 *Cairngorm*
1929
oil on canvas
560 mm x 610 mm
1992.255

91 *Eastre and Fruits*
1929
oil on canvas
640 mm x 535 mm
1992.257

92 *Thorenc Head*
1929
oil on canvas
640 mm x 535 mm
1992.256

93 *At Dinard*
1930-1931 (circa)
oil on canvas
715 mm x 610 mm
1992.258

94 *Bathers and Yachts*
1931
oil on canvas
925 mm x 735 mm
1992.261

95 *Bathers in Green*
1931
oil on canvas
715 mm x 600 mm
1992.262

96 *Megevian*
1931

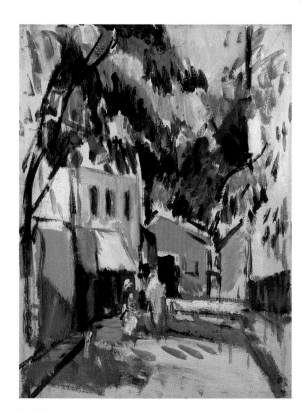

124 *Royan*, 1910 CAT 61

oil on canvas
735 mm × 605 mm
1992.263

97 Morning in Touraine
1931
oil on canvas
650 mm × 545 mm
1992.259

98 Souvenir de Jumièges
1931
oil on canvas
920 mm × 740 mm
1992.260

99 Thorenc: Tilleuls
1931
oil on canvas
550 mm × 650 mm
1992.264

100 Bobbie, Champs Elysées
1933
oil on canvas
305 mm × 460 mm
1992.268

101 La Mousque
1933
oil on canvas
665 mm × 550 mm
1992.266

102 The Ochre Coat
1933
oil on canvas
560 mm × 460 mm
1992.269

103 The Red Hat, Bobbie
1933
oil on canvas
925 mm × 740 mm
1992.267

104 Voile Indienne
1933
oil on canvas
920 mm × 730 mm

1992.265

105 Neon, Café Pousset
1934
oil on canvas
655 mm × 535 mm
1992.272

106 Spring in the South
1934
oil on canvas
735 mm × 915 mm
1992.270

107 Summer 1914
1934
oil on canvas
880 mm × 1135 mm
1992.271

108 Bathers, Evening
1935
oil on canvas
920 mm × 730 mm
1992.274

109 Dancing, Cap d'Antibes
1935
oil on panel
340 mm × 270 mm
1992.273

110 Reclining Golden Nude
1935 (circa)
oil on canvas
665 mm × 765 mm
1992.303

111 Golden Nude
1937
oil on canvas
715 mm × 610 mm
1992.309

112 Déjeuner au Vatel
1938
oil on canvas
915 mm × 735 mm
1992.277

113 Gloxinias and Fuchsias

1938
oil on board
650 mm × 540 mm
1992.276

114 La Châtelaine
1938
oil on canvas
920 mm × 735 mm
1992.279

115 Lillies
1938
oil on canvas
650 mm × 535 mm
1992.278

116 Female Figure in Floral Hat
1941
oil on canvas
813mm × 635mm
1992.281

117 Jeu de Lumière: Portrait of Eileen
1941
oil on board
320 mm × 240 mm
1992.283

118 Kirklee Bridge, Glasgow
1941
oil on canvas
640 mm × 510 mm
1992.284

119 Roses: Pink Roses
1941
oil on canvas
665 mm × 550 mm
1992.280

120 White Flower
1941
oil on card
145 mm × 110 mm
1992.282

121 By the Kelvin

1942
oil on canvas
765 mm × 640 mm
1992.285

122 Dark Trees by the Kelvin
1944
oil on canvas
635 mm × 535 mm
1992.305

123 Mother and Child: Sheila
1944
oil on canvas
765 mm × 615 mm
1992.286

124 Portrait en Rose
1946
oil on canvas
735 mm × 590 mm
1992.288

125 The Indian Curtain
1946
oil on canvas
1290 mm × 865 mm
1992.287

126 Girl with a Bang
1947
oil on canvas
890 mm × 640 mm
1992.289

127 Pique Nique en Provence
1949
oil on canvas
805 mm × 995 mm
1992.290

128 Spring, Botanic Gardens
1950
oil on canvas
650 mm × 535 mm
1992.291

129 The Red Dress, Botanic Gardens
1950

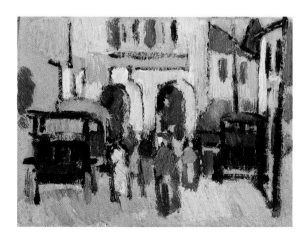

125 *The Grand Hotel, Pourville*, c.1921 CAT 72

126 *Houses in Trees*, c.1925 CAT 80

oil on board
350 mm × 270 mm
1992.292

130 Woman in Hat
1950 (circa)
oil on hardboard
240 mm × 195 mm
1993.261

131 Young Woman with Flowers
1950 (circa)
oil on board
1992.310

132 Bathers: The Parasol
1951
oil on canvas
1020 mm × 1275 mm
1992.293

133 Siesta
1951
oil on canvas
650 mm × 780 mm
1992.294

134 Danu, Mother of the Gods
1952
oil on canvas
1840 mm × 1230 mm
1992.296

135 Head with Roses
1952
oil on canvas
545 mm × 490 mm
1995.951

136 Portrait with Earrings
1952
oil on canvas
395 mm × 290 mm
1992.295

137 The Dome, Botanic Gardens, Glasgow
1953
oil on canvas
640 mm × 535 mm
1992.297

138 Blonde with Checked Sundress
1958
oil on canvas
920 mm × 740 mm
1992.298

139 Chimney Pots
1959

oil on panel
220 mm × 175 mm
1992.301

140 Girl in Flowered Hat
1959
oil on board
260 mm × 330 mm
1992.339

141 Pink Dress, Cap D'Antibes
1959
oil on panel
355 mm × 280 mm
1992.302

142 Sheila: Head
1959
oil on panel
350 mm × 275 mm
1992.299

143 Two Nudes
1959
oil on canvas
1890 mm × 1915 mm
1992.300

Section II
SCULPTURE

144 Head of the Artist
1908
plaster
height 165 mm
1992.416

145 Ténèbres
1915
Dumfries stone
height 380 mm
1992.430

146 The Garden
1915
red sandstone
height 240 mm
1992.429

147 Female Head and Foliage
1916
sandstone
height 280 mm
1992.419

148 Summer: Head of Woman
1916
red sandstone
height 400 mm
1992.420

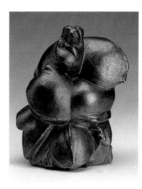

127 Gloxinia, 1919 CAT 150

149 Torse de Femme
1918
bronze
height 150 mm
1992.418

150 Gloxinia
1919
brass
height 80 mm
1992.432

151 Plénitude d'Olivier
1919
brass
height 435 mm
1992.431

152 Dancing Nude
1920 (circa)
plaster
height 160 mm
1992.424

153 Dancing Nude: Effulgence
1920 (circa)
plaster
height 195 mm
1992.426

154 Female Dancer
1920 (circa)
plaster
height 210 mm
1992.421

155 Female Nude
1920 (circa)
plaster
height 25 mm
1992.422

156 Female Nude
1920 (circa)
plaster
height 190 mm
1992.425

157 Fragment Female Torso
1920 (circa)
stone
height 100 mm
1992.423

158 Head and Foliage Carving
1920 (circa)
oak
210 mm 195 mm
1992.434

159 Female Nude: Poise
1920 (circa)
brass
height 230 mm
2000.26

160 Sitting Female Nude
1920 (circa)
plaster
height 75 mm
1992.427

161 Goat
1921
brass
height 215 mm
1992.415

162 Goat
1921
plaster
height 215 mm
1992.436

163 Eastre
1924
plaster
height 410 mm
1992.433

164 Eastre: Hymn to the Sun
1924
plaster
height 410 mm
1992.435

165 Eastre
1924
brass
height 410 mm
1992.437

166 Eastre (original)
1924

carved plaster
height 410mm
1994.1888

Section III
WATERCOLOURS

167 Our House
1897 (circa)
watercolour on paper
135 mm x 140 mm
1992.366

168 The Trocadéro, Paris
c.1902
watercolour on paper
310 mm x 250 mm
1997.466

169 Assiette au Beurre
1907 (circa)
watercolour on paper
300 mm x 240 mm
1992.372

170 Café Scene
1907
watercolour on paper
495 mm x 540 mm
1992.343

171 Self Portrait
1907 (circa)
watercolour and charcoal on
paper
315 mm x 270 mm
1992.373

172 Self Portrait
1909
watercolour and crayon on
paper
153 mm x 160 mm
1993.372.43

173 Couple at the Seaside
1910 (circa)
watercolour and conté on
paper
255 mm x 215 mm
1993.371.5

174 Couple Seated on Beach
1910 (circa)
watercolour and conté on
paper
258 mm x 216 mm
1993.371.1

175 Gentleman Dining
1910 (circa)

watercolour and ink on
paper
310 mm x 385 mm
1992.389

176 Lady and Gentleman
1910 (circa)
watercolour and ink on
paper
390 mm x 310 mm
1992.391

177 Lady with Dog
1910 (circa)
watercolour and ink on
paper
395 mm x 310 mm
1992.390

178 Man with Binoculars
1910 (circa)
watercolour and conté on
paper
285 mm x 205 mm
1993.371.2

179 The Swimming Lesson
1910 (circa)
watercolour and conté on
paper
249 mm x 211 mm
1993.371.6

180 Study for *A Lowland
Church*
1914
watercolour on paper
155 mm x 190 mm
1992.345

181 Costume Design for
Spring Ballet
1914
watercolour and conté on
paper
205 mm x 125 mm
1992.370

182 Flowers
1914 (circa)
watercolour and conté on
paper
208 mm x 127 mm
1992.572.26

183 Spray
1914
watercolour and conté on
paper
275 mm x 205 mm
1992.344

*184 An Impression of Harry
Lauder*
1918
watercolour on paper
475 mm x 240 mm
1992.346

185 Woman in Hat
1920 (circa)
watercolour and conté on
paper
177 mm x 110 mm
1992.182

186 Landscape, Pourville
1921
watercolour and charcoal on
paper
270 mm x 335 mm
1993.24

187 A Perthshire Landscape
1922
watercolour and graphite on
paper
120 mm x 150 mm
1992.386

*188 Margaret Morris at Le
Château des Enfants*
1924
watercolour on paper
330 mm x 255 mm
1992.347

189 Crossing Steamer
1925 (circa)
watercolour on paper
265 mm x 330 mm
1992.367

190 Two Bathers under a Tree
1925
watercolour on paper
260 mm x 315 mm
1992.348

191 Bathers
1926
watercolour on paper
255 mm x 215 mm
1992.349

192 Clouds in Wales
1926
watercolour and conté on
paper
260 mm x 335 mm
1992.351

*193 Margaret Morris at
Summer School, Pourville*

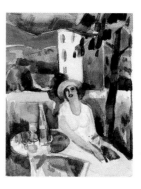

128 *Rita John at Golfe Juan,*
1926 CAT 194

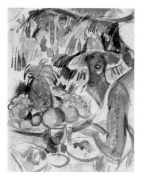

129 *Picnic in Davidson's*
Woods, Cap d'Antibes,
1928 CAT 196

1926
watercolour on paper
330 mm x 260 mm
1992.350

194 Rita John at Golfe Juan
1926
watercolour on paper
255 mm x 205 mm
1992.353

195 Welsh Farm
1926
watercolour on paper
155 mm x 190 mm
1992.352

196 Picnic in Davison's Woods,
Cap d'Antibes

1928
watercolour on paper
255 mm × 210 mm
1992.354

197 *Trees in G.D.'s Woods*
1928
watercolour on paper
390 mm × 260 mm
1992.400

198 *Blonde by the Sea*
1930 (circa)
watercolour on paper
265 mm × 330 mm
1992.364

199 *Nudes with Green Bathing
Caps*
1930 (circa)
watercolour on paper
255 mm × 200 mm
1992.369

200 *Two Bathers, Cap
d'Antibes*
1930 (circa)
watercolour on paper
305 mm × 245 mm
1992.365

201 *Two Bathers in a Wood*
1930 (circa)
watercolour on paper
251 mm × 202 mm
1993.372.52

202 *House Boats, Bourne End*
1931
watercolour on paper
255 mm × 210 mm
1992.356

203 Study for *Megevian*
1931
watercolour and conté
on paper
338 mm × 260 mm
1992.347

204 *Nude and Foliage*
1931 (circa)
watercolour paper
260 mm × 315 mm
1992.355

205 *Dryads, Cap d'Antibes*
1932
watercolour on paper
255 mm × 585 mm
1992.357

206 *Three Bathers under Trees*
1933
watercolour on paper
270 mm × 315 mm
1992.358

207 *Nude against Blue Wash*
1940
watercolour on paper
305 mm × 245 mm
1992.360

208 *Tree and Cactus, Cap
d'Antibes*
1940
watercolour on paper
265 mm × 210 mm
1992.359

209 Study for *The Botanic
Gardens, Glasgow*
1950 (circa)
watercolour and graphite
on paper
162 mm × 103 mm
1993.372.12

210 Study for *The Botanic
Gardens, Glasgow*
1950 (circa)
watercolour and graphite
on paper
124 mm × 132 mm
1993.372.13

211 *Composition*
1955 (circa)
watercolour on paper
210 mm × 260 mm
1992.362

212 *Still Life: Chrysanthemums
and Roses*
1955 (circa)
watercolour and pastel on
paper
165 mm × 215 mm
1992.363

Section IV
DRAWINGS

213 *Girl and Woman in Hats*
1905 (circa)
conté on paper
130 mm × 130 mm
1993.42

214 *The Carriage*
1905 (circa)

conté on paper
115 mm × 180 mm
1992.395

215 *The Hat*
1905 (circa)
conté on paper
115 mm × 98 mm
1992.394a

216 *Self Portrait*
1907 (circa)
conté on paper
255 mm × 190 mm
1992.409

217 *The White Ruff and Other
Portraits*
1908 (circa)
conté on paper
125 mm × 205 mm
1992.374

218 *Café Interior*
1908 (circa)
conté on paper
144 mm × 110 mm
1993.408.46

219 *Blériot*
1909
conté on paper
209 mm × 123 mm
1993.408.144

220 *Blériot*
1909
conté on paper
159 mm × 123 mm
1993.408.145

221 Study for *The Blue Hat:
Closerie des Lilas*
1909 (circa)
conté on paper
209 mm × 128 mm
1993.349.20

222 *Anne Estelle Rice*
1910 (circa)
conté on paper
280 mm × 215 mm
1992.403

223 *A Nude Dancing*
1910 (circa)
conté on paper
125 mm × 215 mm
1992.402

224 *Boy*
1910 (circa)

conté on paper
180 mm × 65 mm
1993.58

225 *Card Players*
1910 (circa)
conté on paper
125 mm × 210 mm
1993.66

226 *Card Players*
1910 (circa)
conté on paper
125 mm × 210 mm
1993.65

227 *Couple Seated in a Café*
1910 (circa)
conté on paper
160 mm × 106 mm
1993.37

228 *Dish of Fruit and Two
Bottles*
1910 (circa)
conté on paper
210 mm × 125 mm
1993.273

229 *Girl in Hat, Holding
Hoop*
1910 (circa)
conté on paper
180 mm × 90 mm
1993.35

230 *Girl on a Couch*
1910 (circa)
conté on paper
125 mm × 205 mm
1992.375

231 *Head of Edie Valray*
1910 (circa)
conté and pastel on paper
125 mm × 190 mm
1992.392

232 *Head of Man*
1910 (circa)
conte on paper
125 mm × 20 mm
1992.394b

233 *Head of a Man*
1910 (circa)
ink on paper
230 mm × 170 mm
1992.408

234 *Head of Woman*
1910 (circa)

conté on paper
210 mm × 123 mm
1998.171

235 *Heart-Shaped Monogram*
1910 (circa)
black ink on paper
32 mm × 32 mm
1993.181

236 *Man in Hat*
1910 (circa)
conté on paper
130 mm × 100 mm
1993.56

237 *Man in Straw-Boater*
1910 (circa)
conté on paper
175 mm × 120 mm
1992.393

238 *Man with a Moustache*
1910 (circa)
conté on paper
190 mm × 125 mm
1992.414

239 *Oriental Face*
1910 (circa)
conté on paper
180 mm × 123 mm
1993.43

240 *Portrait of S. J. Peploe
(1871-1935)*
1910 (circa)
conté on paper
205 mm × 125 mm
1993.57

241 *Preparatory Study for At
My Studio Window*
1910 (circa)
conté on paper
209 mm × 125 mm
1999.53

242 *Seated Peasant Woman
with Basket*
1910 (circa)
conté on paper
207 mm × 125 mm
1993.34

243 *Seated Woman at Café
Table*
1910 (circa)
conté on paper
210 mm × 125 mm
1993.36

244 *Self Portrait*
1910 (circa)
conté on paper
162 mm × 106 mm
1993.33

245 *Self Portrait*
1910 (circa)
gouache and charcoal on
paper
335 mm × 265 mm
1993.27

246 *Self Portrait*
1910 (circa)
pen and ink on paper
110 mm × 80 mm
1992.188

247 *Self Portrait*
1910 (circa)
brush and ink on paper
160 mm × 133 mm
1992.190

248 *Self Portrait*
1910 (circa)
conté and gouache on paper
108 mm × 90 mm
1992.191

249 *Self Portrait*
1910 (circa)
brush and ink on paper
201 mm × 107 mm
1992.193

250 *Self Portrait*
1910 (circa)
graphite on paper
138 mm × 105 mm
1992.194

251 *Self Portrait*
1910 (circa)
brush and ink on paper
122 mm × 76 mm
1992.201

252 *Self Portrait*
1910 (circa)
graphite on paper
125 mm × 104 mm
1992.195

253 *Self Portrait*
1910 (circa)
brush and ink on paper
180 mm × 135 mm
1992.187

254 *Standing Nude*

1910 (circa)
conté on paper
205 mm × 125 mm
1993.62

255 *Study of Children*
1910 (circa)
conté on paper
200 mm × 120 mm
1992.396

256 *Study of a Nude*
1910 (circa)
graphite on paper
200 mm × 125 mm
1992.376

257 *Study of a Nude*
1910
graphite on paper
205 mm × 125 mm
1992.377

258 *Table Setting*
1910 (circa)
conté on paper
208 mm × 126 mm
1993.274

259 *The Square Hat*
1910 (circa)
conté on paper
200 mm × 120 mm
1992.397

260 *Woman in Hat*
1910 (circa)
ink on paper
35 mm × 60 mm
1993.44

261 *Woman in Hat*
1910 (circa)
conté on paper
210 mm × 120 mm
1993.41

262 *Woman on Horseback with
Man Standing*
1910 (circa)
conté on paper
95 mm × 115 mm
1993.165

263 *Woman in Hat with Fan*
1910 (circa)
conté on paper
190 mm × 115 mm
1992.410

264 *Yacht Sailing into
Harbour*

1910 (circa)
conté on paper
125 mm × 210 mm
1993.167

265 *Seated Woman*
1910 (circa)
conté on paper
209 mm × 125 mm
1993.349.40

266 *'1911' Nude*
1911
conté on paper
344 mm × 256 mm
1992.406

267 *Dancing Nude*
1911
conté on paper
205 mm × 125 mm
1992.382

268 *Cover Design The Quest*
1911
conté on paper
205 mm × 125 mm
1992.378

269 *Cover Design Rhythm*
1911
conté on paper
125 mm × 205 mm
1992.379

270 *Cover Design Rhythm*
1911
conté on paper
125 mm × 205 mm
1992.380

271 *Nude in a Studio*
1911
conté on paper
205 mm × 125 mm
1992.381

272 *Nude Study*
1911
conté on paper
282 mm × 209 mm
1993.372.36

273 *Rhythm Headpiece
Decorations*
1911 (circa)
ink on paper
85 mm × 220 mm
1993.198

274 *Self Portrait*
1911

brush and ink and conté on
paper
198 mm × 127 mm
1992.189

275 *Frank Harris*
1911-1912 (circa)
graphite on paper
205 mm × 125 mm
1992.384

276 *Frank Harris*
1911-1912 (circa)
conté on paper
330 mm × 245 mm
1993.61

277 *Self Portrait*
1911-1912 (circa)
graphite on paper
205 mm × 125 mm
1992.385

278 Study for *Torse de Femme*
1912
conté on paper
260 mm × 202 mm
1993.372.39

279 *After the Bath*
1912 (circa)
brush and ink on paper
335 mm × 266 mm
1993.32

280 *Anne Estelle Rice*
1912 (circa)
conté on paper
305 mm × 230 mm
1992.404

281 *Bertha Hubbard and her
Daughter*
1912 (circa)
ink on paper
330 mm × 255 mm
1992.405

282 *Bowl of Fruit and Paraffin
Lamp*
1912 (circa)
conté and ink on paper
200 mm × 125 mm
1992.186

283 *Boxer*
1912 (circa)
conté on paper
205 mm × 125 mm
1993.59

284 *Dish of Fruit*

1912 (circa)
conté and graphite on paper
125 mm × 207 mm
1993.271

285 *Farm Buildings and Pine
Trees*
1912 (circa)
conté on paper
210 mm × 125 mm
1993.63

286 *Figures on a Beach,
Illustrated in Rhythm*
1912 (circa)
conté and ink on paper
175 mm × 103 mm
1993.164

287 *Head of Man, Illustrated
in Rhythm*
1912 (circa)
graphite on paper
175 mm × 115 mm
1992.371

288 *Head of Woman*
1912 (circa)
conté on paper
185 mm × 130 mm
1992.184a

289 *Head of Woman with
Monogram*
1912 (circa)
brush and ink on paper
117 mm × 167 mm
1992.202

290 *Rhythm Headpiece
Decorations*
1912 (circa)
ink on paper
247 mm × 120 mm
1993.199

291 *Rhythm Headpiece
Decorations*
1912 (circa)
ink on paper
93 mm × 194 mm
1993.197

292 *Thoughtful Nude*
1912 (circa)
graphite on paper
313 mm × 238 mm
1992.407

293 *Wine Bottle and Fruit*
1912 (circa)
lithograph and graphite on

paper
185 mm × 130 mm
1992.184b

294 *Woman Seated at Bar,
Illustrated in Rhythm*
1912 (circa)
conté on paper
207 mm × 127 mm
1993.163

295 *Margaret Morris on Stage,
Paris*
1913
ink and conté on paper
338 mm × 232 mm
1993.131

296 *Self Portrait*
1913
ink on card
150 mm × 120 mm
1993.22

297 *Self Portrait*
1913
ink on card
150 mm × 120 mm
1993.23

298 *Nude at Curtain*
1914 (circa)
graphite on paper
340 mm × 265 mm
1996.493

299 *Self Portrait*
1914 (circa)
pen and ink on paper
203 mm × 132 mm
1992.199

300 *Self Portrait*
1914 (circa)
ink on paper
105 mm × 99 mm
1992.200

301 *Self Portrait*
1914
conté on paper
163 mm × 110 mm
1992.192

302 Study for *Summer 1914*
1914
conté on paper
125 mm × 208 mm
1993.408.99

303 *Margaret Morris*
1916

graphite on paper
1993.26

304 Study for *Rose Rhythm*
1916 (circa)
conté on newspaper
260 mm × 215 mm
1992.179

305 Study for *Portsmouth
Docks*
1918
charcoal on paper
215 mm × 165 mm
1994.870

306 *Portsmouth Docks*
1918
pastel on paper
199 mm × 254 mm
1994.868

307 *Portsmouth Docks*
1918
charcoal on paper
199 mm × 254 mm
1994.869

308 Study for *Plénitude
d'Olivier*
1919 (circa)
conté on newspaper
203 mm × 203 mm
1992.178

309 *Architectural Drawing*
1920 (circa)
conté on paper
540 mm × 340 mm
1992.412

310 *Architectural Drawing*
1920 (circa)
graphite on paper
540 mm × 340 mm
1992.413

311 *Head of Woman*
1920 (circa)
conté on paper
127 mm × 77 mm
1992.197

312 *Head of Woman*
1920 (circa)
conté on paper
103 mm × 123 mm
1993.264

313 *Seated Nude*
1920 (circa)
ink and wash on paper

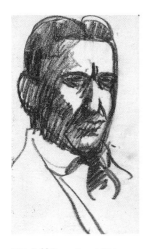

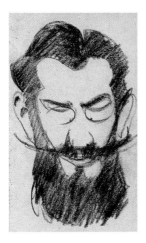

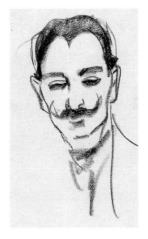

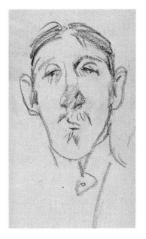

130 *Self Portrait*, c.1911
CAT 354

131 *Portrait of Bearded Man*,
c.1910 CAT 357

132 *Head of Man with
Moustache*, c.1910
CAT 362

133 *Caricature: Head of
Man*, c.1910 CAT 357

425 mm × 445 mm
1993.28

314 *Margaret Morris*
1924 (circa)
graphite on paper
340 mm × 263 mm
1993.30

315 *Head of Margaret Morris*
1925 (circa)
graphite on lined paper
257 mm × 200 mm
1992.180

316 *Hills in Purple Ink*
1925 (circa)
ink on paper
255 mm × 375 mm
1992.401

317 *Male and Female Heads*
1925 (circa)
graphite on paper
323 mm × 245 mm
1992.181

318 *Trees and a Nude*
1925 (circa)
blue crayon on paper
200 mm × 120 mm
1993.68

319 *Woman in Hat*
1925 (circa)

graphite on paper
105 mm × 85 mm
1993.45

320 *Woman in Hat*
1925 (circa)
graphite and pen and ink on
paper
148 mm × 127 mm
1992.185

321 *A Head and a Glass
Tumbler*
1926
pen and ink on card
140 mm × 105 mm
1992.196

322 Study for *Becheron,
Tilleul Trees*
1927
conté on paper
214 mm × 164 mm
1998.226

323 *Boulders and Steps*
1930
graphite on paper
265 mm × 210 mm
1992.387

324 *Boulders*
1930
graphite on paper
265 mm × 210 mm

1992.388

325 Study for *Voile Indienne*
1933
conté on paper
258 mm × 202 mm
1993.372.40

326 *Head of Woman*
1940 (circa)
graphite on paper
170 mm × 215 mm
1993.31

327 *Design for Book Cover*
1943 (circa)
gouache and blue crayon
248 mm × 185 mm
1993.184

328 *Thistle, Cover Design*
1943
graphite on paper
255 mm × 202 mm
1993.200-205

329 *Design*
1944
watercolour on paper
222 mm × 153 mm
1993.206

330 *Baby's Head with Dummy*
1945 (circa)
conté on paper

155 mm × 125 mm
1993.67

331 *Drawing of Rita P.*
1950 (circa)
conté on paper
345 mm × 265 mm
1993.38

332 *Drawing of Rita P.*
1950 (circa)
conté on paper
335 mm × 260 mm
1993.39

333 *Head of Woman*
1950 (circa)
charcoal on paper
280 mm × 395 mm
1993.29

334 *Head of Woman*
1950 (circa)
conté on paper
203 mm × 165 mm
1993.40

335 *Head of Woman and
Foliage*
1950 (circa)
conté on paper
125 mm × 173 mm
1992.198

336 *Head of Woman*

1952 (circa)
graphite on paper
253 mm × 183 mm
1993.268.1

337 Designs
1955 (circa)
graphite on paper
71 mm × 130 mm
1993.265

338 Illustrations for, *In Memoriam James Joyce*
1955
graphite and ink on paper
287 mm × 225 mm
1993.169 – 1993.180

339 Nude and Trees
1955 (circa)
graphite on paper
163 mm × 209 mm
1997.467

340 Profile of Woman, Six, Quatre, Deux
1956
pastel and gouache on newspaper
328 mm × 160mm
1999.404

341 A Building
undated
conté on paper
214 mm × 165 mm
1993.269

342 Foliage of a Vine
undated
conté on paper
115 mm × 110 mm
1993.270

343 Madame
1910 (circa)
conté on paper

190 mm × 115 mm
1992.411

344 Male Figure
undated
graphite on paper
52 mm × 22 mm
1993.60

Section V
SKETCHBOOKS

345 Sketchbook 1
1913
conté on paper
209 mm × 125 mm
1992.447.0-56

346 Sketchbook 2
1905 (circa)
conté on paper
203 mm × 125 mm
1992.449.1-71

347 Sketchbook 3
1910 (circa)
conté on paper
201 mm × 125 mm
1992.450.1-64

348 Sketchbook 4
1910 (circa)
conté on paper
210 mm × 135 mm
1992.451.1-53b

349 Sketchbook 5
1910 (circa)
conté on paper
210 mm × 135 mm
1992.453.1-47

350 Sketchbook 6
1909 (circa)
conté on paper
209 mm × 133 mm

1992.454.0-53

351 Sketchbook 7
1910
conté on paper
208 mm × 134 mm
1992.457.1-43.1

352 Sketchbook 8
1910 (circa)
conté on paper
208 mm × 134 mm
1992.458.0-43.2

353 Sketchbook 9
1914 (circa)
conté on paper
201 mm × 129 mm
1992.459.1-44

354 Sketchbook 10
1911 (circa)
conté on paper
210 mm × 134 mm
1992.460.0-44b

355 Sketchbook 11
1911 (circa)
conté on paper
210 mm × 135 mm
1992.461.1-38

356 Sketchbook 12
1911 (circa)
conté on paper
210 mm × 134 mm
1992.462.0-43

357 Sketchbook 13
1910 (circa)
conté on paper
202 mm × 112 mm
1992.463.1-81b

358 Sketchbook 14
1910 (circa)
conté on paper
201 mm × 123 mm

1992.498.1-54

359 Sketchbook 15
1910 (circa)
conté on paper
175 mm × 118 mm
1992.499.1a-52

360 Sketchbook 16
1911 (circa)
conté on paper
208 mm × 136 mm
1992.526.0-53

361 Sketchbook 17
1912 (circa)
conté on paper
207 mm × 134 mm
1992.543.0-48.2

362 Sketchbook 18
1910 (circa)
conté on paper
208 mm × 133 mm
1992.544.0-36b

363 Sketchbook 19
1912 (circa)
conté on paper
208 mm × 132 mm
1992.545.0-50

364 Sketchbook 20
1910 (circa)
conté on paper
210 mm × 133 mm
1992.546.0-47.1

365 Sketchbook 21
1910 (circa)
conté on paper
208 mm × 135 mm
1992.547.0-49b

366 Sketchbook 22
1909 (circa)
conté on paper
208 mm × 135 mm

134 *Couple Dancing,* c.1910
CAT 371

135 *Standing Nude,* c.1910
CAT 383

136 *Dancing Nude,* c.1910
CAT 383

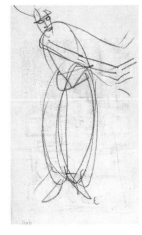

137 *Sketchy Figure in Action,*
c.1911 CAT 356

1992.548.0-53

367 Sketchbook 23
1908 (circa)
conté on paper
210 mm × 128 mm
1992.549.1-44

368 Sketchbook 24
1910 (circa)
conté on paper
209 mm × 133 mm
1992.550.1-42

369 Sketchbook 25
1910 (circa)
conté on paper
210 mm × 133 mm
1992.555.1-41

370 Sketchbook 26
1909 (circa)
conté on paper
209 mm × 132 mm
1992.556.0-57.1

371 Sketchbook 27
1910 (circa)
conté on paper
209 mm × 133 mm
1992.564.0-64b

372 Sketchbook 28
1910 (circa)
conté on paper
208 mm × 133 mm
1992.565.0-64

373 Sketchbook 29
1909
conté on paper
208 mm × 133 mm
1992.570.0-51.1

374 Sketchbook 30
1910 (circa)
conté on paper
208 mm × 132 mm
1992.571.0-57

375 Sketchbook 31
1914
conté on paper
208 mm × 134 mm
1992.572.0-52

376 Sketchbook 32
1910 (circa)
conté on paper
209 mm × 134 mm
1992.573.1-32

377 Sketchbook 33

1910 (circa)
conté on paper
210 mm × 135 mm
1992.821.1-59

378 Sketchbook 34
1910 (circa)
conté on paper
209 mm × 131 mm
1992.822.1-44.1

379 Sketchbook 35
1910 (circa)
conté on paper
209 mm × 133 mm
1992.823.0-43b

380 Sketchbook 36
1910 (circa)
conté on paper
210 mm × 135 mm
1992.849.1-40.1

381 Sketchbook 37
1910 (circa)
conté on paper
209 mm × 135 mm
1992.850.1-50b

382 Sketchbook 38
1910 (circa)
conté on paper
209 mm × 133 mm
1992.851.0-68.1

383 Sketchbook 39
1910 (circa)
conté on paper
208 mm × 133 mm
1992.852.0-53.2

384 Sketchbook 40
1914
conté on paper
206 mm × 133 mm
1992.854.0-54

385 Sketchbook 41
1914
conté and watercolour on
paper
208 mm × 126 mm
1992.855.1a-19

386 Sketchbook 42
1905 (circa)
conté on paper
117 mm × 98 mm
1992.856.1a-11b

387 Sketchbook 43
1905 (circa)

graphite on paper
125 mm × 90 mm
1993.1.1-68b

388 Sketchbook 44
1905 (circa)
graphite on paper
140 mm × 97 mm
1993.2.1-1993.2.15

389 Sketchbook 45
1905 (circa)
graphite on paper
126 mm × 118 mm
1993.3.1-70

390 Sketchbook 46
1908
conté on paper
124 mm × 89 mm
1993.4.0-77

391 Sketchbook 47
1905 (circa)
graphite on paper
107 mm × 173 mm
1993.5.1a-23

392 Sketchbook 48
1950 (circa)
conté and watercolour on
paper
200 mm × 144 mm
1993.6.0-3

393 Sketchbook 49
1930 (circa)
graphite on paper
185 mm × 125 mm
1993.7.0-33

394 Sketchbook 50
1920
conté, graphite and water-
colour on paper
186 mm × 124 mm
1993.276.1-20b

395 Sketchbook 51
1945 (circa)
graphite and watercolour on
paper
180 mm × 140 mm
1993.277.1-11

396 Sketchbook 52
1930 (circa)
conté and watercolour on
paper
185 mm × 125 mm
1993.278.1-4

397 Sketchbook 53
1920 (circa)
graphite on paper
181 mm × 125 mm
1993.279.1-46

398 Sketchbook 54
1950 (circa)
conté on paper
145 mm × 100 mm
1993.321.1-86

399 Sketchbook 55
1955 (circa)
graphite and watercolour on
paper
169 mm × 108 mm
1993.322.1-6

400 Sketchbook 56
1950 (circa)
graphite and watercolour on
paper
184 mm × 125 mm
1993.323.1-9

401 Sketchbook 57
1950 (circa)
graphite and watercolour on
paper
181 mm × 184 mm
1993.324.1-7

402 Sketchbook 58
1955 (circa)
graphite and watercolour on
paper
252 mm × 195 mm
1993.325.1-16 and
1994.1887.1-12

403 Sketchbook 59
1950 (circa)
graphite on paper
203 mm × 165 mm
1993.346.1-103

404 Sketchbook 60
1945 (circa)
graphite on paper
210 mm × 133 mm
1993.347.1-59

ENDNOTES

1. The two principal sources of information about the artist's life and work at present are J.D. Fergusson's unpublished notes written in preparation for his autobiography (c.1955-61) and Margaret Morris's, *The Art of J. D. Fergusson: A Biased Biography* (Glasgow, 1974).

2. J.D. Fergusson, *Modern Scottish Painting*, (Glasgow, 1943), p.49.

3. Ibid., p.37.

4. Ibid., p.41.

5. J.D. Fergusson quoted by Margaret Morris in *The Art of J. D. Fergusson*, 1974, p.50.

6. J.D. Fergusson, 'Memories of Peploe', *Scottish Art Review*, Vol. VIII, No.3, 1962, p.8.

7. Ibid., pp.9–10.

8. The back of a photograph showing Jean's face reflected in a hand-mirror is inscribed, 'How do you like the puddin' face in the glass', Fergusson Gallery Archive, photograph ref., 1993.1022.

9. Fergusson Gallery Archive, letter ref., 1998.91.

10. Extract from Fergusson's introductory statement to exhibition catalogue, *Paintings by J. D. Fergusson*, The Baillie Galleries (London, 1905).

11. Haldane MacFall, 'The Paintings of John D. Fergusson RBA', *The Studio*, 1907, pp.209-210.

12. J.D. Fergusson, *Modern Scottish Painting*, p.70.

13. J.D. Fergusson's notes in a Paris sketchbook, Fergusson Gallery Archive, ref:1992.545, pp 42a-43b.

14. J.D. Fergusson quoted by Margaret Morris in *The Art of J. D. Fergusson*, p.46.

15. J.D. Fergusson, 'The Autumn Salon', *Art News*, 21 October 1909.

16. J.D. Fergusson quoted by Margaret Morris in *The Art of J. D. Fergusson*, p.53.

17. Ibid., p.63.

18. J.D. Fergusson, 'Memories of Peploe', *Scottish Art Review* Vol. VIII, No.3, 1962, p.31.

19. Holbrook Jackson, 'J.D. Fergusson & his Pictures', *To-day*, Vol. 3, 1918, p.108.

20. Ibid., p.108

21. John Middleton Murry, *Between Two Worlds*, 1935, p.155

22. Ibid., p.156.

23. Sheila McGregor's unpublished M.Phil thesis and forthcoming monograph are the sources of research on *Rhythm* art journal.

24. J.D. Fergusson quoted by Margaret Morris in *The Art of J. D. Fergusson*, p.47.

25. Ibid., p.79.

26. J.D. Fergusson, 1 April 1914, Fergusson Gallery Archive, letter ref: 1994.1859.1–5.

27. Margaret Morris, *The Art of J. D. Fergusson*, pp.94–95.

28. Frank Rutter, exhibition catalogue foreword, *Pictures by John Duncan Fergusson*, Doré Galleries, (London 1914).

29. Margaret Morris, *Margaret Morris Dancing*, 1925, p.86.

30. J.D. Fergusson quoted by Margaret Morris in *The Art of J. D. Fergusson*, p.103.

31. John Middleton Murry (ed.), *The Journal of Katherine Mansfield 1904–1922*, 1974, pp.123–124.

32. J.D. Fergusson quoted by Margaret Morris in *The Art of J. D. Fergusson*, p.108.

33. Ibid., p.199.

34. Ibid., p201.

35. Margaret Morris, *The Art of J. D. Fergusson*, p.138.

36. Margaret Morris, *My Life in Movement*, 1969, p.138.

37. Margaret Morris, *The Art of J. D. Fergusson*, p.138.

38. Charlie MacArthur, *John Duncan Fergusson*, foreword to exhibition catalogue, Whitney Studios, 1926.

39. J.D. Fergusson quoted by Dorothy Dayton, *The New York Sun*, 1928.

40. S.J. Peploe copy of letter to J.D. Fergusson, Fergusson Gallery Archive letter ref: 1994.1894.

41. Margaret Morris, *The Art of J. D. Fergusson*, p.178.

42. Copies of *The Scots Socialist*, *The Voice of Scotland*, *Scottish Journal*, *The New Scot*, and *The Nationalist and National Weekly* are amongst those titles found in the Fergusson Gallery Archive.

43. Roland E. Muirhead (1868–1964) Chairman of the Scottish Nationalist Party, reply to J.D. Fergusson, letter ref: 1994.416, Fergusson Gallery Archive.

44. J.D. Fergusson, *Modern Scottish Painting*, p.7.

45. Ibid., p.87.

46. Ibid., p.69.

47. Ibid., p.69.

48. Maurice Lindsay, *Francis George Scott and the Scottish Renaissance*, 1986, p.208.

49. Margaret Morris, 'The Celtic Ballet of Scotland', *The New Scot*, November 1946, p.30.

50. Extract from J.D. Fergusson's foreword to, *The New Scottish Group*, (Glasgow, 1947), p.5.

51. Louise Annand unpublished note of 1974, written as one of a collection of tributes to J.D. Fergusson by various members of the New Art Club, letter ref: 1994.1941. 2, Fergusson Gallery Archive.

52. Raymond Drey, 'Some Memories of J.D. Fergusson', *Apollo*, October 1962, p.623.

53. Again, these issues are discussed in Sheila McGregor's forthcoming monograph.

54. Extract from Robins Millar, 'The Man Who Found The Rainbow', *Glasgow Evening Citizen*, 5 May, 1948.

55. T.J. Honeyman, 'J.D. Fergusson', *The Scottish Field*, March 1955, p.45.

56. Extract from J.D. Fergusson's prefatory note in Hugh MacDiarmid's *In Memoriam James Joyce*, 1955, p.10.

CHRONOLOGY

1874	Born 7 Crown Street, Leith in Edinburgh, of Perthshire parents, 9 March.
1880s – 90s	Family moves house three times; 77 Ferry Road, 16 East Hermitage Place, 16 East Claremont Street.
1886	Attends Royal High School, Edinburgh.
1889	Transfers to Blair Lodge, a school near Linlithgow. Here his Art and French are encouraged.
c.1892	Maintains that he studied Medicine for two years, although there are no matriculation records at Edinburgh University to support this.
c.1895	Decides to pursue art full-time. After a short spell as a student at the Trustees Academy, Edinburgh, leaves to become self-taught, working initially in watercolour.
c.1897	Begins regular visits to Paris and the north coast of France. Sees French Impressionist paintings in the Salle Caillebotte and Durand Ruel's Gallery, Paris.
1898	Exhibits watercolours of French subjects at the Royal Scottish Academy and the Society of British Artists.
1899	Travels to Morocco, following in the footsteps of Glasgow Boy, Arthur Melville (1855–1904).
c.1900	Forms close friendship with fellow artist Samuel John Peploe (1871-1935).
c.1900–05	Annual painting holidays to coastal resorts of north-west France with Peploe.
1901	Travels to Spain.
1902	Moves to first studio in Picardy Place at the top of Leith Walk, Edinburgh. Paints in Peebles, Edinburgh, Fife, Islay, London and Paris.
1903	Elected member of the Royal Society of British Artists. Matisse, Derain and Vlaminck exhibit at the Salon des Indépendants, Paris. First performance of *Danse-Idylles* by Isadora Duncan and *Schéhérezade* by Maurice Ravel in Paris.
1905	First solo exhibition at the Baillie Galleries, London. Begins to spend longer periods of time in Paris. James McNeill Whistler (1834–1903) Memorial Exhibition in Paris. Fauves exhibit at the Salon d'Automne, led by Matisse.
1906	Spends summer with the artist Samuel John Peploe touring the Normandy coast. Death of Paul Cézanne.
1907	Settles permanently at 18 boulevard Edgar Quinet, Paris. Exhibits at the Salon d'Automne for the first time. Meets the American artist Anne Estelle Rice (1879-1959) with whom he shares a close relationship over the next six years. Teaches part-time at the Académie de la Palette and there meets his lifelong friend, the artist Dunoyer de Segonzac (1884–1974).
1908	Meets the American sculptor Jo Davidson (1883–1952) and makes his first recorded sculpture.
1909	Moves to a studio at 83 rue Notre Dame des Champs. Paints at Montgeron. Paris, première of Diaghilev's production of Mussorgsky's *Boris Gudonov*. Cubist Movement begins.
1909	Elected a sociétaire of the Salon d'Automne. Futurist Manifesto issued concurrently in Milan and Paris. Isadora Duncan dances at the Gaîté Théâtre, Paris. Matisse commissioned to paint *Dance* and *Music*.
1909–14	Paris, premières of Diaghilev's *Ballet Russes*.
1910	Paints with Peploe and Rice in Royan. First meeting with John Middleton Murry

	(1889–1957). Dunoyer de Segonzac illustrates albums on Isadora Duncan and *Schéhérezade*.
1910 & 1912	Roger Fry's Post-Impressionist Exhibitions, London.
1911	Launch of *Rhythm* magazine by John Middleton Murry and Michael Sadler in London, with Fergusson as Art Editor. Paints with Peploe in Royan.
1912	Katherine Mansfield (1888–1923) replaces Michael Sadler as Co-Editor of *Rhythm*.
1913	Meets the dancer Margaret Morris (1891–1980) in Paris, who becomes his lifelong partner. Four works included in the Post-Impressionist & Futurist Exhibition, Doré Galleries, London. Visits Cassis with Peploe and Rice. Settles in Cap d'Antibes. Collaborates with de Segonzac and other artists to design illustrations for Francis Carco's *Chansons aigres-douces*. *Rhythm* journal succeeded for three issues by the *Blue Review*. Anne Estelle Rice marries Raymond Drey and settles in London.
1914	Forced to leave Cap d'Antibes on outbreak of First World War and returns to London to be with Margaret Morris.
1914–18	The war years spent between his family and Peploe in Edinburgh and Margaret Morris in London. Rents a studio at 14 Redcliffe Road, London.
1915	Helps Margaret Morris to establish her Club in Glebe Place, Chelsea. Margaret Morris performs her *Spring* ballet. Charles Rennie Mackintosh (1868–1928) settles in London and becomes a close friend.
1917	First Margaret Morris Summer School held at Combe Martin, Devon. In the 1920s, '30s and '50s held regularly in France.
1918	Commissioned by the Ministry of Information to make a series of paintings of life in naval dockyards, Portsmouth. Moves to new studio at 15 Callow Street, London, his base for the next 11 years. Marriage of Katherine Mansfield and John Middleton Murry with Fergusson as a witness.
1922	Tours the Highlands with the journalist and writer John S.M. Ressich (1878–1937) and paints *Highland Landscape* series.
1923	First Scottish solo shows in Glasgow and Edinburgh.
1924	Exhibits at the Galerie Barbazanges, Paris, with fellow Colourists; Peploe, George Leslie Hunter (1877–1931) and Francis Campbell Boileau Cadell (1883–1937). First exhibition in America at the Whitney Studios, New York.
1928	Visits America for his exhibition at the Kraushaar Galleries, New York. Charles Rennie Mackintosh dies.
1929	Re-settles in Paris. Studio in the rue Gazan near the Parc de Montsouris.
1930s	Makes regular visits to the South of France during the summers and to Jo Davidson in the Loire Valley. Acts as President of the Groupe d'Artistes Anglo-Américains, Paris.
1931	Les Peintres Écossais Exhibition, Galeries Georges Petit, Paris. Fergusson's painting, *La Déesse de la Rivière*, purchased by the French Government.
1932	Rents new studio at 6 square Henri Delormel, Paris.
1939	Settles permanently in Glasgow with Margaret Morris at 4 Clouston Street, following the outbreak of the Second World War.
1940	Founds the New Art Club with Margaret Morris, who also establishes the Celtic Ballet.
1942	The New Scottish Group formed, comprising members of the New Art Club.
1943–48	New Scottish Group annual exhibitions, McClure's Gallery, Glasgow.
1943	*Modern Scottish Painting* is published by MacLellan.
1948	First major retrospective exhibition at the McLellan Galleries, Glasgow. Tours to Aberdeen, Ayr, Carlisle, Paisley and Belfast.

1950	Awarded an honorary LLD by Glasgow University.
1951 & 1953	New Scottish Group Exhibitions, McLellan Galleries, Glasgow.
1954	J.D. Fergusson Retrospective-Exhibition (touring) Arts Council of Great Britain Scottish Committee.
1956	New Scottish Group and Other Independents Exhibition, McLellan Galleries, Glasgow.
1950–60	Annual trips to the South of France to teach and paint at Margaret Morris's Summer Schools.
1961	Dies 30 January, Glasgow.

DATES OF KEY INDIVIDUALS

Adler, Jankel (1895–1949)
Annand, Louise (b.1915)
Banks, Dorothy 'Georges' (active c.1911)
Bakst, Léon (1866–1924)
Bax, Arnold (1883–1953)
Bear, Telfer (1876–1973)
Bergson, Henri-Louis (1859–1941)
Bonnard, Pierre (1867–1947)
Bourdelle, Antoine (1861–1929)
Bridie, James [O. Henry Mavor] (1888–1951)
Cadell, Frances Campbell Boileau (1883–1937)
Camoin, Charles (1879–1965)
Cézanne, Paul (1839–1906)
Chabaud, Auguste (1882–1955)
Chisholm, Eric (1904–1965)
Coburn, Alvin Langdon (1882–1966)
Crosbie, William (1915–1999)
Davidson, Jo (1883–1952)
Davison, George (1855–1930)
Derain, André (1880–1954)
Diaghilev, Sergei (1872–1929)
Dismorr, Jessica (1885–1939)
Dobson, Frank (1888–1963)
Dongen, Kees Van (1877–1968)
Drey, O. Raymond (1885–1977)
Duncan, Isadora (1877–1927)
Dunlop, Ronald Ossary (1894–1973)
Elder, Andrew Taylor (1908–1966)
English, Harold (1890–1953)
Epstein, Jacob (1880–1959)
Friesz, Othon (1879–1949)
Galsworthy, John (1867–1933)
Gaudier-Brezska, Henri (1891–1915)
Ginner, Charles (1879–1952)
Goncharova, Natalia (1881–1962)
Goossens, Eugene (1893–1962)
Herman, Josef (1911–2000)
Honeyman, Dr Thomas J. (1891–1971)
Hornel, Edward Atkinson (1864–1933)
Hunter, George Leslie (1877–1931)
Jaques-Dalcroze, Émile (1865–1950)
John, Augustus (1878–1961)

Joyce, James (1882–1941)
Konody, Paul G. (1872–1933)
Larionov, Mikhail (1882–1964)
Lewis, Wyndham (1882–1957)
MacDiarmid, Hugh (1892–1978)
Macdonald, Margaret (1864–1933)
Mackintosh, Charles Rennie (1868–1928)
MacLellan, William (1919–1996)
Maconochie, Jean (dates unknown)
Manet, Édouard (1832–1883)
Mansfield, Katherine (1888–1923)
Marquet, Albert (1875–1947)
Marshall, John Macmillan (1879–1948)
Matisse, Henri (1869–1954)
Melville, Arthur (1855–1904)
Moreau, Luc-Albert (1882–1948)
Morris, Margaret (1891–1980)
Murry, John Middleton (1889–1941)
Nicholson, Winifred (1893–1981)
O'Connor, Roderick (1860–1940)
O'Shaunessy, Sheila [nee. Neill] (b.1915)
Peploe, Samuel John (1871–1935)
Picasso, Pablo (1881–1973)
Pound, Ezra (1885–1972)
Reid, Alexander (1854–1928)
Ressich, John (1878–1937)
Rice, Anne Estelle (1877–1959)
Rimsky-Korsakov, Nikolay (1844–1908)
Roche, Alexander (1861–1921)
Rutter, Frank (1876–1937)
Sadler, Michael (1888–1957)
Sargent, John Singer (1856–1925)
Segonzac, André Dunoyer de (1884–1974)
Simpson, Joseph (1879–1939)
Stravinsky, Igor (1882–1971)
Thompson, Marguerite (1889–1968)
Toulouse-Lautrec, Henri de (1864–1901)
Vlaminck, Maurice de (1876–1968)
Walker, Ethel (1861–1951)
Walton, George (1867–1933)
Whistler, James Abbott McNeill (1834–1903)
Young, Douglas (1913–1973)

BIBLIOGRAPHY

J.D. Fergusson's writings

Prologue, *Paintings by J.D. Fergusson*, Exhibition Catalogue, The Baillie Gallery, London 1905

Review, 'The Autumn Salon', *The Art News*, 21 October 1909

Modern Scottish Painting (McLellan, Glasgow 1943)

'Art and Atavism: The Dryad', *Scottish Art and Letters*, No.1, 1944, pp. 47–49

Foreword in, *The New Scottish Group* (McLellan, Glasgow 1947)

'Chapter from an Autobiography', *Saltire Review* VI, no.21, 1960, pp. 27–32

'Memories of Peploe', *Scottish Art Review*, Vol.8, no.3, 1962, pp. 8–12

Autobiographical notes and other unpublished writings: The Fergusson Gallery Archive, Perth, Scotland

Unpublished sources

Annand, Louise, 'The Centre at Scott Street: 1941-42', chapter for a forthcoming publication concerning J.D. Fergusson's involvement in the 1940s–'60s Glasgow art scene

Blackwood, Jonathon, 'The Sculpture of J.D. Fergusson', unpublished seminar paper, Courtauld Institute of Art 1988

McGregor, Sheila, 'J.D. Fergusson: The Early Years, 1874-1918', unpublished M.Phil. thesis, Courtauld Institute of Art 1981

McGregor, Sheila, forthcoming monograph on J.D. Fergusson

Secondary Sources

Antliff, Mark, *Inventing Bergson: Cultural Politics and the Parisian avant garde* (Princeton 1993)

Billcliffe, Roger, *The Glasgow Boys* (John Murray, London 1985)

Billcliffe, Roger, *The Scottish Colourists* (John Murray, London 1989)

Billcliffe, Roger, *J.D. Fergusson 1874–1961* introduction to exhibition catalogue, The Fine Art Society, London 1974

Crawford, Alan, *C.R. Mackintosh, The Chelsea Years*, exhibition catalogue, Hunterian Art Gallery, University of Glasgow 1994

Cumming, E., Drummond, J., McGregor, S., *Colour, Rhythm and Dance*, exhibition catalogue texts, Scottish Arts Council 1985

Drey, Raymond, 'Some Memories of J.D. Fergusson', *Apollo*, October 1962, pp. 622–24

Dunoyer de Segonzac exhibition catalogue, Royal Scottish Academy, Arts Council of Great Britain 1960

Easton, M. and Drey, R., *Anne Estelle Rice* (1879–1959) introduction to exhibition catalogue, Hull University 1969

Farr, Dennis, *New Painting in Glasgow*, exhibition catalogue, Scottish Arts Council 1968

Gale, Iain, *Arthur Melville* (Atelier Books, Edinburgh 1996)

Geddes, Jean, (ed.), *Café Drawings in Edwardian Paris from the Sketchbooks of J.D. Fergusson 1874–1961* (Blackie, Glasgow and London 1974)

Greenwood, Jeremy, *Omega Cuts*, (Suffolk 1998)

Hardie, William, *Scottish Painting: 1837 to the Present*, (Studio Vista, London 1990)

Hartley, Keith, *Scottish Art Since 1900*, exhibition catalogue, Scottish National Gallery of Modern Art 1989

Herman, Josef, 'Notes from a Glasgow Diary: 1940-43', *Scottish Art Review*, Vol. 13, No.3, 1972

Honeyman, T.J., 'J.D. Fergusson', *Scottish Field*, March 1955, pp. 44-46

Hopkinson, Martin, 'The Prints of J.D. Fergusson', *Print Quarterly*, Vol.XVI, No.2, June 1999, pp.163-167

Jackson, Holbrook, 'J.D. Fergusson and his Pictures', *To-Day* (III), 1918, pp. 108-11

Konody, Paul, G., *Pictures, Sculpture, Pottery by some British Artists of To-day*, introduction to exhibition catalogue, Lefèvre Galleries, London 1925

Lea, F.A., *The Life of John Middleton Murry* (Methuen, London 1959)

Lindsay, Maurice, *Francis George Scott and the Scottish Renaissance* (Paul Harris, Edinburgh 1980)

Low, Bet, 'We Were Always Cold', *Scottish Review*, No.7, August 1996

MacDiarmid, Hugh, *In Memoriam James Joyce* (McLellan, Glasgow 1955)

MacFall, Haldane, 'The Paintings of John D. Fergusson R.B.A.', *The Studio*, XL, 1907, pp. 202-210

Macmillan, Duncan, *Scottish Art in the Twentieth Century* (Mainstream, Edinburgh 1994)

Macmillan, Duncan, *Scottish Art 1460–2000* (Mainstream, Edinburgh 2000)

Mansfield, Katherine, *Prélude* (London 1918)

Marriott, Charles, 'J.D. Fergusson – His Place in Art', *Colour*, June 1918, pp. 98-102

Marriott, Charles, 'Building in Paint', *Land and Water*, May 1918, p20

McGregor, Sheila, *John Duncan Fergusson 1874–1961*, introduction to exhibition catalogue, Duncan Miller Fine Arts, London, 1990

McIsaac, Nigel, 'John Duncan Fergusson', *Scottish Art Review*, VII, No.3, 1960, pp.20-23

McLaren Young, Andrew, *J.D. Fergusson Memorial Exhibition*, exhibition catalogue, Arts Council of Great Britain, Scottish Committee 1961

Morris, Margaret, *My Galsworthy Story* (Peter Owen, London 1967)

Morris, Margaret, *My Life in Movement* (Peter Owen, London 1969)

Morris, Margaret, *Creation in Dance* and Life (Peter Owen, London 1972)

Morris, Margaret, *The Art of J.D. Fergusson: A Biased Biography* (Blackie, Glasgow 1974)

Morris, Margaret and Daniels, Fred, *Margaret Morris Dancing* (London 1925)

Murry, John Middleton, *Between Two Worlds* (Johnathan Cape, London 1935)

Murry, John Middleton (ed.), *The Journal of Katherine Mansfield 1904–1922* (London 1954)

Nathanson, Carol A., 'Anne Estelle Rice: Theodore Dreiser's Ellen Adams Wrynn', *Woman's Art Journal*, Fall 1992/Winter 1993, Vol. 13, No.2, pp. 3-11

Nathanson, Carol A., *The Expressive Fauvism of Anne Estelle Rice,* exhibition catalogue, Hollis Taggart Galleries, New York 1997

Normand, Tom, 'J.D. Fergusson and the Culture of Nationalism in Scotland', *Études Écossaises*, No.5, 1998

Parsons and Gale, *Post-Impressionism* (Studio Editions, London 1992)

Peploe, Guy, *S.J. Peploe 1871–1935*, exhibition catalogue, Scottish National Gallery of Modern Art, Edinburgh 1985

Rhythm: Art, Music, Literature Quarterly, 1911–1913

Robins, Anna Gruetzner, *Modern Art in Britain 1910–1914*, exhibition catalogue, Barbican Art Gallery, London 1997

Rutter, Frank, *Post-Impressionist and Futurist Exhibition*, introduction to exhibition catalogue, Doré Galleries, London 1913

Rutter, Frank, *Pictures by John Duncan Fergusson* introduction to exhibition catalogue, Doré Galleries London 1914

Rutter, Frank, *Some Contemporary Artists* (Leonard Parsons, London 1922)

Sickert, Walter, *Paintings by S.J. Peploe, Leslie Hunter, F.C.B. Cadell and J.D. Fergusson,* introduction to exhibition catalogue, Leicester Galleries, London 1925

Spencer, Charles, *Leon Bakst and the Ballet Russes* (Academy Editions, London 1995)

Sykes, Diana, *J.D. Fergusson 1905–15*, exhibition catalogue, Crawford Arts Centre, University of St. Andrews 1982

Third Eye Centre, *Margaret Morris: Drawings and Design and the Glasgow Years,* Glasgow 1985

Third Eye Centre, *William MacLellan: A Pioneering Publisher,* Glasgow 1987

Watt, Alexander, 'J.D. Fergusson', *The Artist*, XIII, 1937, pp.86-89

THE FERGUSSON GALLERY

When J.D. Fergusson died in 1961, Margaret Morris inherited a substantial collection of his work and memorabilia. Realising the future significance of the collection, she established the J. D. Fergusson Art Foundation in 1963.

Comprising oil and watercolour paintings, drawings, sketchbooks and sculptures, the Fergusson Foundation Collection was the largest and most important holding of Fergusson's work in existence. Loans to major exhibitions were regularly made, but the Foundation had no permanent home for the safe storage and display of the collection and its extensive associated archive. The Foundation's principal aim was to make Fergusson and his works more widely accessible to the public. With heightened awareness in the 1970s and 1980s of the significance of his contribution to Scottish art, the need for a permanent centre for the study and appreciation of Fergusson's work became greater.

In 1990 several bodies, including Perth & Kinross District Council, were approached by the Foundation and invited to submit proposals on how they would curate and make accessible the collection if it were transferred outright to them.

A submission based on the conversion of the Perth water works, a category-A listed building of 1832 and the appointment of professional staff was made by Perth & Kinross. This was considered and subsequently approved by the Foundation. The formal signing over of the Fergusson Collection and copyright in all of Fergusson's works to the Council took place in November 1991. Conversion of the building was completed later that year, enabling the collection to be gathered from its various temporary locations and finally brought together under suitable conditions of storage, access and display, for the first time in its history.

On 6 March 1992, The Fergusson Gallery was formally opened by Sir Norman McFarlane KT, in the presence of a distinguished and invited

company. The success of the entire project was recognised, appropriately enough, on St Andrews Day, 30 November 1992, when The Fergusson Gallery was named as winner of the Post Office Scottish Museum of the Year Award. With its creation, a permanent memorial has been achieved to one of the most important and influential Scottish Artists of the 20th Century.

In their colouring, its off-white walls reflect Fergusson's own immaculately kept studios. Their curvature, provides the ideal foil to the curvaceous sensuality of the female nudes who so fascinated and absorbed him. In its programme of rotating displays, drawn from the unparalleled permanent collection, it provides unrivalled access to Fergusson the man and Fergusson the artist.

It is domestic in feel. It is unstuffy and informed. It positively shines, evoking the splendid light and warmth of the Mediterranean, which so captivated him when he first encountered it in 1913 and which he cherished for the rest of his life. Fergusson's dream has been realised. Fergusson lives again.

<div align="right">

Robin H. Rodger
Principal Officer Fine and Applied Art
Perth & Kinross Council
2000

</div>

INDEX